Czechoslovak Prints from 1900 to 1970

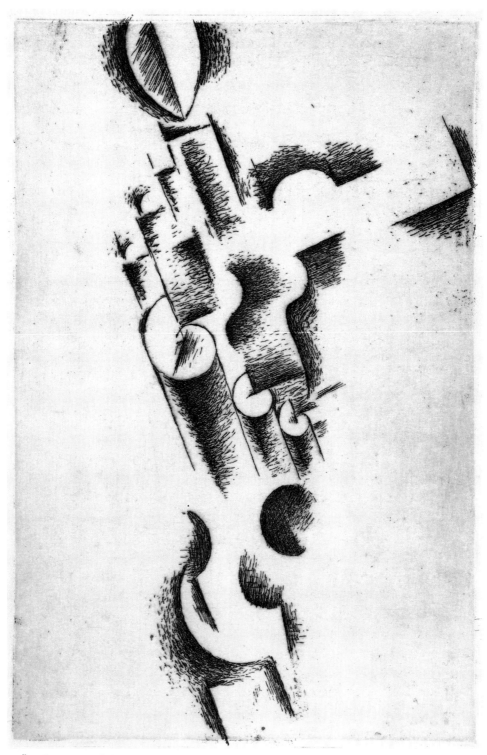

35 Čapek, Figure called Lelio. 1913

Czechoslovak Prints
from 1900 to 1970

Irena Goldscheider

Published for the Trustees of the British Museum
by British Museum Publications Limited

© 1986 Trustees of the British Museum

Published by British Museum Publications Ltd
46 Bloomsbury Street, London WC1B 3QQ

Cataloguing in Publication data
British Museum
 Czechoslovak prints, 1900–1970.
 1. Prints, Czechoslovakian——Catalogs
 2. Prints, 20th century——Czechoslovakian
 ——Catalogs
 I. Title II. Goldscheider, Irena
 769.9437'074 NE735.C9

ISBN 0–7141–1631–9

Designed by James Shurmer

Set in Monophoto Apollo
and printed in Great Britain by
Jolly & Barber Ltd, Rugby, Warwickshire

Contents

Preface

This exhibition is the result of an exchange which has few precedents in the history of the British Museum. Its origins go back to the winter of 1982–3 when we were delighted to show in our galleries a loan exhibition of medieval treasures under the title 'Greater Moravia', which had been assembled and catalogued on our behalf by Czechoslovakian scholars. This was followed in the summer of 1983 by an exhibition of prints and drawings by Wenceslaus Hollar. Hollar was born in Prague, but spent much of his life in London, and is the first significant etcher in the history of print-making in both Britain and Czechoslovakia. The exhibition drew on the excellent collections of his work in the British Museum and the National Gallery in Prague, and was shown in virtually the same form in both Britain and Czechoslovakia.

So successful was our collaboration with Academician Kotalík and his colleagues in the National Gallery that we jointly decided to embark on a quite different sort of undertaking: instead of exchanging exhibitions, we should exchange collections. We therefore assembled in London a collection to give a survey of the British print from Blake and Gillray to Paolozzi and Hockney. Some part of it was already available as duplicates in the Department of Prints and Drawings, but most prints had to be specially purchased. The British Museum Society gave a very generous grant to make this possible.

The collection assembled on our behalf in Prague is now catalogued and exhibited to the British public. It is, to the best of our knowledge, the first historical survey of twentieth-century Czech printmaking to have been shown outside Czechoslovakia, and is therefore an event of considerable significance. We hope that the remarkable originality of vision of Czech printmakers and the consistently high quality of their work will be a revelation to our visitors.

It remains for me to express my thanks in the first place to Academician Kotalík, who apart from his distinction as an art historian and museum director, has also played a significant role in the history of Czech art as a member of Group 42 in a capacity as critic and theoretician. Without his support this exchange could never have succeeded. Secondly I must thank Dr Jana Wittlichova in Prague for her efforts in assembling the collection, and Mrs Irena Goldscheider in London for writing the catalogue. Finally I must thank the British Museum Society both for their generous initial gift, and for a second grant which has paid for the costs associated with the catalogue. In the Department of Prints and Drawings, Mr Antony Griffiths has been responsible for the practical details, which included editing the catalogue and writing the introduction in collaboration with Mrs Goldscheider.

David M. Wilson
Director, British Museum

Introduction

The modern state of Czechoslovakia was created by the Treaty of Versailles at the end of the First World War. It was formed from three main regions: Bohemia to the west, Moravia in the centre, and Slovakia in the east. The last of these is occupied by Slovaks, with their own traditions and language; the first is the home of the Czechs. The works described in this catalogue are almost entirely the work of Czech or Moravian-born artists, and most were made in the capital of Bohemia, Prague.

Throughout the Middle Ages and the Renaissance, Bohemia was an independent kingdom, and for many years the seat of the Holy Roman Emperor. Under the king was a powerful local nobility, fiercely jealous of its prerogatives, and to a large part protestant in religion. This strong local autonomy was definitively crushed in 1620 at the Battle of the White Mountain outside Prague by the forces of the Austrian Hapsburg and Catholic Empire. Most of the Bohemian nobility was executed or exiled, and replaced by a new German-speaking aristocracy. By the end of the eighteenth century the very survival of the Czech language seemed in doubt, and it was the task of the Czech national revival of the nineteenth century to re-establish the language and recreate the literature. Czech music was founded by Bedřich Smetana, and his 'Bartered Bride' of 1866 was an enormous popular success. It was followed by the beginning of work on a new National Theatre in 1868, which was completed in 1881. This also affected the history of Czech art, for the first generation of independent Czech painters came together in the decoration of this theatre.

Wenceslaus Hollar (1607–77; his first name in Czech is Vaclav) is probably still the best-known Czech printmaker internationally. But he left Prague shortly after the Battle of the White Mountain for Germany and eventually England, and founded no tradition in Bohemia. At the beginning of the nineteenth century a printmaking workshop was opened at the Academy of Fine Arts in Prague, and it produced a number of etchings, engravings and aquatints which were linked with the landscape school then flourishing there. This workshop closed in 1818, and a tradition of printmaking can only be fitfully discerned through the nineteenth century. The most significant figure was Julius Mařák (1835–99), a professor of painting at the Academy, who made some twenty-five landscape etchings himself in the 1860s and 1870s, and taught the subject on an informal basis to a number of his students, among them Švabinský.

It was only in the 1890s that artists began to look at the medium of printmaking with greater interest. This decade was of course one of tremendous artistic ferment throughout Europe, and the new recognition of the importance of the decorative arts gave an increased artistic validity to such minor genres as printmaking. In Prague a School of Applied Arts had already been founded in the 1880s alongside the long-established School of Fine Arts, and in 1887 the Mánes Union of Artists had been

established, named after Josef Mánes (1820–71), a founding figure of Czech painting and renowned for his romantic interpretations of scenes from Czech history. From 1897 it held an annual exhibition of members' work, and from 1902 a series of exhibitions of the work of foreign artists (mentioned later in this essay). Knowledge of developments abroad was gained from foreign magazines (for printmaking the most important was the Viennese periodical *Die Graphischen Künste*) and from occasional imported exhibitions held in Prague. Of Czech magazines of great interest for printmaking was the *Moderní Revue* founded in 1894. The editor was Arnošt Procházka, and an important contributor the Czech decadent poet Karel Hlaváček, who contributed three rather bad etchings of his own as illustrations. But most of the plates were of the leading foreign artists of the period, and thus a Czech audience became familiar with the work of Redon, Rops, Gauguin, Bernard and Munch. Of more general importance was the later artistic journal *Volné Směry* (Free Trends) founded in 1896, which included many reproductions of paintings and sculptures by the artists it was discussing.

The most famous Czech artist of the 1890s is Alfons Mucha (1860–1939), who was trained abroad in Vienna and Munich, before settling in Paris in 1888. He achieved instant fame in 1894 with the success of his first poster for Sarah Bernhardt. Mucha finds no place in this exhibition as his work belongs to the field of applied graphics rather than original printmaking. But a number of printmakers who are included here followed a similar early career abroad, often after an initial training in Prague. Among them are Šimon who worked for a number of years in Paris, and Preissig who as the ablest printmaker of his generation is also the saddest case. Between 1897 and 1903 he worked in Paris to perfect his knowledge of the processes of printing and printmaking. On his return he founded a firm to specialise in producing fine books, posters and prints, but this failed. He also made a series of coloured etchings (cat. 14–16) of remarkable technical assurance and artistic quality; these he marketed in the United States rather than Prague, and eventually emigrated there in 1910. He returned to Czechoslovakia in 1930, only to die in a concentration camp after being arrested for his activities in printing resistance literature.

A surer market could be found for less unusual prints, and it is not surprising that the backbone of the production of the first generation of Czech specialist printmakers in the first years of the twentieth century was formed by views of Prague and of its topography. The leading light was a woman, Zdenka Braunerová, whose enthusiasm for the medium of etching seems to have inspired a number of other artists. She was trained in the techniques by Eduard Karel, who returned to Prague from Vienna in 1899. Others among Karel's pupils were Úprka and later Švabinský. With Švabinský we meet the central figure in what we might call institutionalised printmaking in twentieth-century Czechoslovakia. He was equally skilled as painter, draughtsman and printmaker (both etcher, lithographer and mezzotinter). His mildly symbolist subjects, and his numerous female nudes, were widely popular, and he was the obvious choice for the first holder of a professorship of printmaking which was established at the Prague Academy in 1910. He left this in 1926 when promoted to the professorship of painting, which he held until his retirement in 1939. Widely

despised by several younger generations of avant-garde artists, he was honoured with the title of 'National Artist' in 1945.

In 1904 Švabinský won a gold medal for his prints at the St Louis centennial exhibition. This event can be seen (with hindsight) as the coming of age of the Czech print. From that date onwards events began to move very fast, and in the decade to the outbreak of the First World War a number of major talents emerged. These can be roughly divided into two groups, which worked more or less in parallel but independently of each other: one is of mainly Symbolist inspiration (sometimes called 'second-generation' symbolists, the first generation being the painters of the 1880s and 1890s), while the other follows international developments very closely.

The first group betrays a peculiarly Czech genius and is impossible to parallel in other countries. Probably for this reason it has remained totally neglected abroad, and the names of Bílek, Kobliha and Váchal are still unknown. If this exhibition manages to do something to change this, it will have succeeded. Bílek was primarily a sculptor, who from the mid-1890s created a series of wooden carvings in low relief with mysterious combinations of parts of human figures and forms set into indeterminate spaces. These mystical creations were given such transcendental titles as 'The interpretation of the word Madonna' and 'The oppression of the body, of the world and of the firmament'. So it is not surprising that when he turned to printmaking, he soon concentrated on wood-engraving and that he handled it in a very peculiar and individual way. The most striking is the 'Entrance to the Temple' (cat. 17), where he has used a section from the trunk of a tree as it came to hand, and conjured forms out of it. Bílek's mysticism is foreign to the Anglo-Saxon temperament and his type of figures do not fit into the classic tradition of western draughtsmanship. However, his work does fall in the centre of the Czech and central European consciousness. Parallels can be found in the early coloured aquatints of František Kupka, made before his emergence as one of the pioneers of abstract painting.

Váchal was an even more remarkable figure than Bílek. He was trained as a printer, and then briefly studied landscape painting. In 1906 he turned to printmaking, first etching and in 1909 wood-engraving. By 1911 he had developed an exceptional technique of printmaking, which allowed him both to print a wood-engraving in colour, and to combine text and illustration in a number of extraordinary books that he produced himself. Most often he cut the text and illustration together in a way that will remind an English audience of William Blake (whose work he presumably knew if only in reproduction), but sometimes he made use of movable type that had been cast to his own design. According to the issue of *Veraikon* of 1934 devoted entirely to his work, he was responsible for 26 books written and illustrated by himself, and a further 26 he illustrated to other people's texts. Of this total of 52, 34 were printed and published by himself between 1908 and 1934, usually in tiny editions. In 1934, on his fiftieth birthday, Váchal decided that his artistic career had come to an end, and left Prague for the country to devote himself to his dogs and books. Before doing so he wrote and published an account of how he made his colour woodcuts: he used a combination of intaglio and relief inking using inks of different viscosities, so that a colour impression could be obtained from a single block in one

printing operation. Váchal may have derived from Bílek the idea of wood-engraving, but his form of mysticism was very different. What is most striking at first is its bizarre humour, but it would be a great mistake to think that he was really poking fun at Symbolism. In fact it was because Váchal was a genuine mystic and eccentric that his world was quite real enough for him to see its humorous side.

The third artist was František Kobliha. Between 1909 and 1914 he made various cycles of wood-engravings, of which the inspiration was almost entirely literary. Many of his prints were in fact published in *Moderní Revue*. Relying entirely on the contrast of black and white, he succeeded in creating a number of remarkable images which are perhaps as much romantic as symbolist in feeling. But they are certainly not mystical. Although Bílek being by now a successful and senior figure stood apart, both Váchal and Kobliha exhibited with the group Sursum, which held two exhibitions in Prague in 1910 and 1912 before fading out. Among the other exhibitors was Konůpek, who seems to have depended more on Klimt and the Viennese school for his inspiration (the three works by him in this exhibition come from a later phase of his career), and Zrzavý, who is mentioned later in this essay as one of the group of Tvrdošijní.

The necessary precondition for the establishment of the parallel group of avant-garde artists before the First World War was the increasing internationalism and self-confidence of the outlook of Czech artists. Beginning in 1902 with a large exhibition of French Impressionist paintings, Prague was host to a number of important shows which decisively affected Czech painters. In 1905 no less than 80 paintings and 40 prints by Munch were exhibited; in 1907 French Impressionist and Post-Impressionist paintings, in 1909 Bourdelle, and in 1910 French Independents, including Matisse and Derain. At the same time Czech artists continued to make frequent voyages abroad, and many stayed for shorter or longer spells in Paris. Similarly foreign artists, among them members of the Brücke from Dresden, made journeys to Prague.

The first group to be established in Prague under the inspiration of these events was the Osma (the Eight), which included Filla and Kubišta among its members. Its style was in general expressionist, emerging from the painting of Van Gogh and Munch. The group was dissolved in 1909 after holding only two exhibitions, and succeeded in 1911 by a more wide-ranging 'Group of avant-garde artists', the centre of whose interest was Cubism. The group was formed after a secession from the Mánes Union, and in it Filla and Kubišta were joined by Čapek, Špála and the sculptor Otto Gutfreund. The Group held its own annual exhibitions in 1912 to 1914, which included works by its members and by foreign guests, among them Derain, Picasso, Delaunay, Mondrian, Kirchner and Schmidt-Rottluff. In 1912 it contributed to an exhibition in Munich and to Walden's Erster Deutscher Herbstsalon in Berlin. It also published a monthly magazine to which many of the foremost critics of the day contributed. Among these was the art historian and collector Vincenc Kramář; by August 1914 he owned over forty Cubist paintings by Picasso and Braque – unquestionably one of the major collections of the period, and now one of the glories of the National Gallery in Prague where most of them have passed.

Against this background it is not surprising that Prague found itself the home of perhaps the most flourishing school of Cubist painting outside Paris. This episode is reasonably well-known abroad thanks to a number of loan exhibitions from Prague (among them one in the Tate Gallery in 1967), and there is less need to dwell on it in this introduction. The high priest of the movement was Filla, and it seems to have been his dogmatic intransigence that led Čapek, Špála and others to leave the 'Group of Artists' and rejoin the Mánes Union in 1912. The most charismatic member was Kubišta, whose originality and promise were cut off by his early death in 1918. All this had an echo in printmaking, although this medium held no more central a place in the activity of these Czech artists than it did in the work of Picasso or Braque. The purest Cubist etchings were those made by Filla, which are not represented in this exhibition. But an outstanding etching by Čapek is included, as well as examples of the more idiosyncratic 'Cubo-Expressionist' creations of Kubišta and Špála.

The outbreak of the First World War inevitably disrupted this activity. Kubišta was already enrolled in the army since poverty had forced him to look for some living. Although he survived the War, he was completely isolated from his colleagues, and then tragically died in November 1918 from the same wave of Spanish influenza that carried off Apollinaire and many others. Filla was isolated in Holland during the War, and had also cut himself off by his insistence on his form of pure Cubism, and so it was left to Čapek and Špála to join with others in the newly founded group called Tvrdošíjní (literally 'The Steadfast or Staunch Ones', better put into French as 'Les Obstinés'), which had gathered together around the periodical *Červen* (June) published by the writer and poet S.K. Neumann. They held their first exhibition in 1918 and the last in 1924 after which the group quietly faded out. It had no well-defined programme, but the title pointed to its central concern which was to keep alive faith in the potentialities of the new means of expression that had been pioneered in the pre-War years. From the third exhibition in 1921 other artists were invited to participate, and thus it was responsible for the introduction of many of the main figures of the next generation of Czech artists.

Of the other founder members, the most significant were Zrzavý and Kremlička. Both of these had been exhibiting before the First World War, but although influenced by French painting had been relatively untouched by Cubism. Kremlička moved from an interest in the Impressionists and Cézanne towards a fascination with large female figure compositions of a highly stylised variety with great emphasis on the purity of contour in the manner of Ingres. In some ways his paintings provide an interesting parallel to the contemporary neoclassical paintings by Picasso. At first glance Zrzavý may appear to be a similar artist, but this would be a mistaken impression. His figures are indeed ovoid, but the distortions are not in the least neoclassical in intention. A sight of the lurid anti-naturalistic colour of his paintings will show that we are again in the presence of a quite original talent. Interestingly one of the few to have recognised it abroad was Giorgio de Chirico who praised it in a characteristically penetrating article first published in 1935. Whereas Kremlička was something of a public figure, and a critic, Zrzavý was a solitary individualist whose influence on later Czech Surrealists owed nothing to his own efforts. Neither however

was particularly interested in printmaking as a medium, and the lithographs that they made are versions of earlier paintings.

The foundation of the Czechoslovak republic in 1918 with its constitution adopted in February 1920 and the new hopes attendant upon it, could not fail to inspire artists. To the new generation, many of whom had fought in the War, it seemed a matter of urgent duty that their art should address itself to as wide a public as possible. Hence the so-called 'social trend' which is such a dominant feature of Czech art of the 1920s. The most remarkable instance of this is to be found in the work of the sculptor Otto Gutfreund (1889–1927). Before the War he had been one of the finest Cubist sculptors, and created a number of masterpieces, mostly cast in bronze. From the early 1920s we find instead groups of men at work in an apparently naive popular style, carved in wood and then painted in bright colours. Gutfreund's influence was decisive on most contemporary Czech sculptors, but there was a parallel movement in printmaking, itself in essence an even more popular art. The chief representatives of this to be seen in this exhibition are Silovský, Rambousek, Sedláček and Holý.

All four had been pupils of Švabinský at the print section in the Prague Academy, and were therefore highly competent technicians in the art of printmaking. Silovský was primarily a graphic artist, while the others were as much printmakers as painters – unlike of course the members of the 'Group of Artists' and the Tvrdošíjní who were only occasional printmakers. This explains in part the variety of techniques that we find being used by them: in particular colour lithography makes its first appearance in this exhibition. Their subject-matter concentrates almost exclusively on scenes from everyday life, narrated in a factual yet sympathetic way and usually without any moralistic or hortatory intent. This distinguishes them sharply from their German contemporaries of the 'Neue Sachlichkeit' (whose fascination is tinged with horror) or even American printmakers of the 1920s (whose subject is usually the city and the way it dwarfs its population). It is also the reason why the term 'social' is more properly applied to the group than 'socialist'.

Their success confirmed the rise in the status of printmaking that had been steadily proceeding since the beginning of the century. The growing number of practitioners and their desire for some professional recognition lay behind the foundation in 1917 of the Association of Czech Graphic Artists, named after Hollar, the first and greatest of Czech printmakers. It acquired an exhibition hall near the National Theatre, where annual exhibitions were held. In 1923 it sponsored the publication of the periodical *Hollar*, which appeared regularly until 1971. Moreover in the later 1920s it promoted a number of exhibitions of contemporary Czech printmaking which were seen in the main cities of Europe. The exhibition of 1927 in London and Brighton described in the preface was one of these. Even if many of the exhibits were conventional, the degree of interest in the medium and the quantity of the production would have been unthinkable a decade or two before. After Švabinský's departure in 1927, Šimon took over the direction of the print school in the Academy which, by not changing with the times, found itself increasingly isolated from the new avant-garde. Thus by the late 1920s and during the 1930s the situation in Czechoslovakia was similar to that in most other European countries: an abundant production from an increasing

number of specialist printmakers depended on a decreasing number of patrons, who were likely to get tired of an exercise that was becoming sterile. To find really interesting prints in these years we have to look among other groups of artists.

In painting the dominant style of the 1930s was Surrealism. This emerged from the avant-garde group 'Devětsil', and made its first public impact in the large international exhibition entitled *Poésie 1932*, which included a large invited element from Parisian Surrealists. Czech artists welcomed avidly the new discoveries of Dali, Mirò and Ernst, and their inventions can be spotted reappearing in new forms and guises in many Czech paintings. But Surrealism no more lent itself as a style to printmaking in Czechoslovakia than it did in France. The only prints in this exhibition that may be connected with the movement are the three by Šima, and even here the link is perhaps more apparent than real. Šima in fact left Czechoslovakia at the age of thirty in 1921, and ended up in France where he married a French woman and took French nationality. But he always maintained his contacts with Prague, and sent many works to exhibitions there. It was around 1926 that he discovered his own world of detached torsos and egg-like forms, with a strong literary flavour. The three prints in this exhibition come from one of his first and most successful series of prints, in which his compositions face poems translated from the French into Czech.

Another artist who lived for a number of years in France was Tichý, but he also maintained links with Prague by sending works back to exhibitions. After his return in 1936 he held a position of considerable importance in Czech artistic life. Although he did not form part of any group, the quality of his work was apparent to all, and exerted a great influence on the younger generation of painters. He only really took up printmaking in 1938, and in the years after the Second World War this medium became more important to him than painting. Thus his influence, strong in any case, was particularly marked in the field of printmaking.

In 1934 a group of young painters, including Gross and Hudeček, whose style was surrealist in inspiration, came together around the critic J. Chalupecký. In this gathering can be seen the germ of the Group 42, founded in 1942 during the Nazi occupation of Prague. In this Gross and Hudeček were joined by Lhoták, Smetana, Souček and Kotík (among the artists included in this exhibition). The group took for its programme a belief that Surrealism was now finished and that a new art had to be forged out of the materials provided by everyday life; their subject, as Chalupecký their theoretician explained, should be the investigation of the poetic value of the modern world. In this search their Surrealist past was of great value, and is responsible for the very individual style which the members adopted, at once more realistic and recognizable in its iconography, but still strange in its manner of expression. The sinister and mechanistic visions of human life that they conjured up matched well the dislocated times of their creation. In the history of Czech printmaking this group plays a major role, for, perhaps because of the difficulties of working on a larger scale, and because of their desire to reach a wider audience, they were the first important avant-garde artists to use the medium extensively since the First World War. Within the general programme of the group there was considerable scope for differences of approach, and this explains the fertility and richness of its production.

The War took a terrible toll on Czech artists. Čapek and Preissig died in concentration camps, and Filla's health never recovered from his internment. But in the history of Czech art, as in the history of the country, the end of the War in 1945 is less significant than 1948 when the Communists came to power following the general election. The following decade during which Stalinism took an iron grip on all aspects of the country's life was not a propitious time for painters or printmakers. The Group 42 was disbanded in 1948, and most of its members abandoned printmaking.

Against this background it is hardly surprising that the first signs of a new beginning are only visible in the late 1950s. One change that must have affected developments was the establishment of a number of specialist schools for printmaking and graphics in Prague and elsewhere. This means that children can now decide to specialise in the field between the ages of fifteen and eighteen. Further education continues to be available at the Academy (where Silovský was head of department from 1945–60), and in the School of Applied Arts (where the course was run by Sklenař from 1970–6).

The new generation of up-and-coming artists and printmakers consisted mostly of men and women in their mid-30s. New associations began to be formed, among them M 57 which included Tesař, and UB 12 which included John and Kučerová. An increasing open-mindedness led to some large retrospective exhibitions of twentieth-century Czech art being held in Prague, and to Czech artists increasingly sending their work to international exhibitions held abroad. In the field of printmaking this led to such symbols of success as John's silver medal at São Paulo in 1963, and the prize awarded to his wife Adriena Šimotová at Ljubljana in the 1970s.

In this exhibition only a small number of the many printmakers now practising in Czechoslovakia can be included. It is certain that many good and important artists will have been omitted (among them Jiri Anderle who is perhaps the best-known contemporary Czech printmaker abroad), and possibly some have been included that future students will regard as insignificant. Perhaps it is permissible here merely to single out the remarkable etchings of Boudník, whose unconventional life and early death in 1968, induced by chronic alcoholism, have already begun to be cloaked in legend. We think that this is the first time that his prints – and those of many, perhaps most, of the other artists included – have been shown to a British public, which can now discover for itself a school of twentieth-century printmaking of rare quality.

*denotes illustration

1 The Founding Generation

Zdenka Braunerová

1858 Prague
1934 Prague

Painter and graphic artist, a very strong personality and enlightened woman who played an important role at the beginning of modern Czech graphic art.

She came from a cultivated background and spent part of her life (including studies at the Academie Collarossi) in France. She was always in the centre of a dynamic cultural life and some foremost Czech and French painters and writers were among her closest friends. Braunerová started her career as a painter. Her landscape painting, influenced by the French Barbizon School, forms a major part of her work. In 1886 she visited London and was impressed by the high standard of book-craft in England and by the wide-ranging activity of such personalities as William Morris. She herself tried out various media, including painted glass, but is now best known for her pioneering work in book design.

At the turn of the century she was concerned about the so-called renovation process which took place in Prague and during which some old parts of the city were callously destroyed. She tried to preserve the image of old Prague in her drawings and prints:

'I felt that Prague asked for prints, that in etchings one could express the magic of its old culture and beauty best. So I longed to fight for the beauty of old Prague in my etchings and filled my sketch books with drawings of the remaining endangered parts of the Prague Ghetto', wrote Braunerová in her memoirs published in *Hollar* in 1923.

These drawings (most often in pencil) served as models for prints. There are only forty-three of these, some of them known in a very small number of impressions. Most are etchings, occasionally combined with aquatint. Her article about the beginnings of Czech printmaking is an important first-hand source for the end of the nineteenth century. With particular gratitude she remembered Eduard Karel who taught her basic printmaking techniques at a time when very few people in Prague knew anything about it.

Bibliography: Prokop H. Toman, *Zdenka Braunerová, Popisný seznam grafického díla*, Prague 1963

1. Nocturne in the Malá Strana

1904
Etching; 195 × 180mm
1985–11–9–30
Signed

Malá Strana (Lesser Town) together with the Staré Město (Old Town) on the other side of the river is the most charming part of Prague where many splendid old buildings (including Prague Castle) can be found. This particular print shows Všehrdova Street in Malá Strana, where Braunerová lived. It is a romantic night scene, in which the effects of light have been achieved by wiping highlights out of a film of surface ink during printing.

*2. Platnéřská Street

1904
Etching; 336 × 181mm
1985–11–9–31

Platnéřská Street was one of the main streets in Staré Město (Old Town) in Prague, with many beautiful old houses. Braunerová's first print, which showed the northern part of the street, had been shown in various exhibitions and was the first Czech print to be reproduced in the *Studio*. This etching shows the southern part of the street (now totally rebuilt). Four drawings preceded this print, two of which are in the National Gallery in Prague.

*3. Maislova Street

1904
Etching; 230 × 150mm
1985–11–9–32
Signed

The light from a street lamp is an important expressive element in this print, of which the real subject is the people, most of them children, and their night gathering and playing, rather than the street and its architecture. There is a warm, intimate atmosphere which is unusual in Braunerová's earlier and more matter-of-fact prints.

Jóža Úprka

1861 Kněždub near Strážnice (Moravia)
1940 Hroznová Lhota (Moravia)

Painter and printmaker.

Studied painting at the Prague (1881–4) and Munich Academies, and afterwards travelled around Europe, living for some time in Paris. Zdenka Braunerová introduced him to Eduard Karel, who taught him printmaking and helped him to set up his own studio. From 1900 his prints were shown in exhibitions along with his paintings. Between 1899 and 1909 he created twenty-three engravings and one woodcut. For these he made numerous preparatory drawings; moreover many are known in different states.

In 1904 he settled in Moravia, in a small village called Hroznová Lhota, where most of his paintings and prints were created. He was fascinated by local folklore and customs, and the subjects of his art are peasants, their work, their habits and their folk art; they are shown in profile, either as individual figures with their working tools or in groups, gathered for festive occasions and dressed in traditional costumes. Úprka's interest in folk art stemmed from the renewed nationalistic feelings in Bohemia and his work was successful. He was represented in many major shows in Prague and elsewhere in Paris, Vienna, Berlin, Cologne, Düsseldorf and in 1904 in St Louis. He is recognised as one of the founders of Czech printmaking, although he is more appreciated for his paintings.

Bibliography: Jan Rambousek, 'Grafika Jóži Úprky', *Hollar* 1932, p.1

*4. Slovak with Hoe

1900
Etching; 240 × 163mm
1985–11–9–118
Annotated 'Svému členu na rok 1901 SVU Mánes' (SVU Mánes to their members for the year 1901)

One of the earliest prints by Úprka, showing the strong influence of Hanuš Schwaiger, his teacher in the Academy. It was used as a 1901 New Year Premium which was distributed to the members of SVU Mánes (Union of Artists). Most of Úprka's prints were simple in technique, yet strong in effect, as is this example.

5. Rider (from the King's Ride)

1903
Etching; 140 × 190mm
1985–11–9–119

The King's Ride is a flamboyant Moravian folk ceremony, one of the most important festivals in the year. Participants wear traditional, elaborately embroidered costumes.

Max Švabinský

1873 Kroměříž
1962 Prague

Painter and outstanding draughtsman and printmaker.

Švabinský enjoyed a long career of a successful and celebrated artist. He was one of the key personalities of Czech printmaking in the first half of this century, co-founder of Hollar and founder of the Print Department at the Prague Academy in 1910 (of which he remained in charge until 1927). After finishing his studies at the Prague Academy in 1898 he set off for a trip around Europe, which included Paris and Holland where he went especially to see Rembrandt's prints. Although he was trained primarily as a painter, at the Academy he had already learned printmaking briefly under J. Mařák and later Eduard Karel. His early prints were based on numerous preparatory pen-drawings, and by 1904 he had mastered printmaking to such an extent, that he received a Gold medal for one of his prints in St Louis.

His early paintings were influenced by the Pre-Raphaelites and French Symbolists, while in his printmaking Whistler was of great importance. In subject-matter his work covers two main areas: nature and portraits. The early prints were the result of direct observation of nature, while later in the 1920s he turned often to allegoric scenes. He created a whole gallery of brilliant portraits of personalities from the Czech art world in drawings and prints.

The complete catalogue of Švabinský's graphic work contains over 800 items. He mastered several printmaking techniques and always achieved a high standard of craftsmanship. In this he was probably the most professional printmaker that ever lived in Czechoslovakia. In 1945 he was among the first artists honoured with the title of National Artist.

Bibliography: Ludvík Paleníček, Zuzana Švabinská, *Max Švabinský – grafické dílo*, Narodní Galerie, Prague 1976

The three following prints were published under the title 'Osm leptů a kresby' (Eight Etchings and Drawings) by Jan Štenc in 1911 in Prague.

*6. Summer Day

1908
Etching; 618 × 515mm
1985–11–9–109
Paleníček No. 46
Signed

From 1906 Švabinský frequently visited the family of his wife to-be who lived in Kozlov. It was there that his drawings (leading later to prints) of gigantic trees with ladies and their umbrellas originated. 'Summer Day' is full of light and peace, and a wonderful example of Švabinský's lyricism and sensualism.

*7. Summer Night

1911
Mezzotint; 550 × 490mm
1985–11–9–110
Páleníček No. 55
Signed

This is usually considered to be a counterpart to the previous print, although its date is later.

Švabinský has chosen the softest of printmaking techniques to bring out the poetical and lyrical character of this scene. Light is an important expressive element: the beam spreading from the middle of the print is in sharp contrast to the darkness of the unlit area. Yet the aim here was not to dramatise, but to evoke the magic atmosphere of night.

*8. White Camellia

1911
Mezzotint; 508 × 418mm
Páleníček No.56
1985–11–9–111

Whilst in the two previous prints we can observe the influence of Impressionism on Švabinský, here he takes over a rather formal composition of mid-nineteenth-century paintings, and the spontaneity of his drawings and prints inspired by nature is lacking.

Several elements in the print are often found in Švabinský's paintings from this period: the bird, camellia, and above all the nude. What we have to admire is the technical virtuosity and the softness of modulation.

Arnošt Hofbauer

1869 Prague
1944 Prague

Painter and printmaker, professor at the School of Applied Arts in Prague, co-founder of SVU Mánes (Union of Artists).

After finishing his studies at the Prague Academy he moved to Vienna where he made his living as a designer for a theatre company. At the turn of the century, he travelled extensively around Europe and learned printmaking techniques from Henri Rivière in Paris. This initiated a period of relatively intensive activity in printmaking, dominated by experiments in the technique of Japanese woodcut. His etchings are rare; the best known of them is 'Tiger's Head' which proved his talent for dealing with animal subjects, and led him later to illustrate Kipling.

He is highly regarded for his applied graphics, and his posters are among the best Czech examples in the Art Nouveau style.

*9. Hradčany in Winter

1903
Colour woodcut; 165 × 217mm
1985–11–9–44
Signed

A colour wood-cut, printed from three blocks with the fourth colour created by overprinting. It shows probably the best known view of Prague Castle seen from the Embankment of the Vltava (Moldau) river.

Viktor Stretti

1878 Plasy near Pilsen
1957 Prague

Originally a painter, later mainly a printmaker, and one of the most active promoters of modern printmaking in Bohemia, founder member of Hollar and its Chairman for some years.

Trained at the Prague School of Decorative Arts and at the Academy, he belongs to the generation of artists for whom journeys abroad (to Munich, Paris, Belgium and occasionally to London) were considered a necessary part of their artistic training. He first encountered etching under J. Mařák at the Academy and tried it out in a poster design before systematically learning printmaking techniques under Peter Halm in Munich

in 1898. From 1899 he regularly showed his prints in Prague's Rudolfinum along with paintings by his colleagues. In coloured etchings, aquatints and mezzotints he found an ideal way to combine his painterly point of departure with his talent for printmaking, and although he continued with painting for some time, it was for his prints that he first gained widespread recognition. Landscapes, portraits and Prague motifs are his most frequent subjects. In 1913 he visited London where he met Joseph Pennell (1860–1926). Both artists were impressed by their meeting; several lithographs of London views (Hyde Park, Tower of London) originated during his visit and with the help of Pennell were printed here. The importance of Stretti's visit to London is expressed by him in an article in *Hollar* in 1932.

Bibliography: A. Novák, 'Viktor Stretti – seznam grafického díla', Supplement to *Hollar*, Prague 1933–39

*10. View of the Castle from the Deer Moat

1907

Etching with Aquatint; 240 × 300mm

1985–11–9–101

Signed

A view of Prague Castle from Palacký's Embankment, made by Stretti in 1898 is now considered to be the first 'modern' print on the Prague theme. Prague motifs dominated in Stretti's work in the period between 1903 and 1910. Like Braunerová and Šimon, Stretti shows great admiration for the city, and depicts its beauty in various moments of the day and the year. 'Prague Nocturne' and 'The Green Market' are among his best known prints on this subject.

Tavik František Šimon

1877 Železnice near Jičín
1942 Prague

One of the founders of twentieth-century Czech printmaking, active member and for many years Chairman of Hollar.

Trained as a painter under M. Pirner at the Prague Academy till 1900, he soon set off for his frequent trips abroad (to Bosnia and Dalmatia first, to Italy, Belgium, France and England in 1902). In 1904 he settled for a few years in Paris where he was close to the community of Czech artists, which included Mucha, Preissig and Kupka. He also became acquainted with French and English graphic artists, joined the Société de la Gravure en Couleur in Paris and in 1910 became an associate member of the Royal Society of Painter – Etchers and Engravers in London. He was greatly impressed by Whistler's posthumous exhibition which he reviewed in a Czech periodical *Volné Směry* in 1905. Šimon made his first print in 1898 and his early work is influenced by Pre-Raphaelites and turn-of-the-century Symbolism. But his style soon changed towards immediate description of nature and city scenes (frequently the streets of Paris) for which he gained a high reputation. Although more or less self taught, he fully mastered various printmaking techniques. In colour etching, engraving and aquatint and combinations of several techniques he found an ideal media to achieve the unusually strong atmospheric effects he sought. His work was fairly popular and was shown in numerous exhibitions both in Prague (the first in 1905–6) and outside Czechoslovakia in Chicago, Paris, London and New York. Šimon published two books on printmaking techniques: *Příručka pro malíře-grafika, rytina, lept a barevný lept* (Manual for printmaker Engraving, Etching and Colour Etching) in 1921, and *Dřevořez* (Woodcutting) in 1926–7. Both were widely used for instruction at a time when there was hardly any literature on this subject in Czechoslovakia. His high reputation was confirmed when he was nominated in 1928 to succeed Max Švabinský as Head of the Print Department at the Prague Academy.

Bibliography: A. Novák, 'Kronika grafického díla T.F. Šimona', *Hollar* XIII (1937), p.49

*11. The Wind

1907
Etching; 248 × 320mm
1908–10–14–336
Purchased from Messrs Dulau

Šimon's early work shows his remarkable sense for a direct recording of experience from nature, in this case from the seaside.

12. New York at Night

1927
Colour Etching; 435 × 333mm
1985–11–9–105

Šimon travelled a great deal and cities in general attracted his attention. This print is a result of his trip to New York and proves his Impressionist sense for atmosphere.

Adolf Kašpar

1877 Bludov
1934 Železná Ruda

Illustrator, painter and printmaker.

After an initial training as a teacher, he went to Prague to study painting at the Academy (1900–4). At the same time he was taught printmaking techniques privately by Alessandro de Pian and Eduard Karel.

His first prints (mainly etchings and aquatints) date from his student years in Prague; they reflect partly his love for the city and partly his interest in the theatre, circus and literature. In 1907 he travelled to Munich where he learned lithography which became his favourite technique after the First World War. In 1908 he got married and his family life became a new source of inspiration as seen in portraits of his wife and daughter. But in general his printmaking was fairly limited later in his career and although prints form an interesting part of Kašpar's work, he is predominantly known for his book illustrations in which his narrative talent, realistic method and sense for detail were at their best.

Bibliography: Adolf Kašpar, exhibition catalogue, Národní Galerie v Praze, Palác Kinských, Prague 1978

*13. Puppet Theatre

1906
Etching; 485 × 640mm
1985–11–9–54
Signed

In 1905 Kašpar travelled to Lnáře, in the Bohemian countryside, where he made drawings and prints depicting scenes from a travelling puppet theatre run by a lady named Kopecká; this particular print is probably the best known of them. The scene from one of the performances is unusually dramatic for Kašpar, with the sharp contrast between the lit and dark area in the theatre.

Vojtěch Preissig

1873 Světec near Bílina
1944 Dachau Concentration Camp

An important member of the founding generation of Czech printmakers and graphic designers, an illustrator, later also a painter.

In 1897 Preissig graduated from the School of Decorative Arts in Prague (with a degree in drawing) and via Vienna and Munich went to Paris, where he became an assistant in Mucha's workshop. In Paris he absorbed the Art Nouveau atmosphere, designed (with William Morris in mind) carpets and wallpapers, and systematically took up printmaking. He learned etching and engraving at the Graphic Academy, spent one year working in the woodcutting workshop of August Schmid and studied Japanese printmaking techniques. In 1902 his first series of colour etchings *Pleasures at the Fireplace* were published.

In 1903 he returned to Prague. A year later he founded a typographic workshop which was intended as a centre for promoting modern Czech graphics. There he printed excellent posters and books and published a series of contemporary prints called *Česká grafika* (Czech Prints), in which Kupka, Švabinský, Šimon and Stretti were among the artists chosen to represent the best contemporary printmaking in Bohemia. The Czech public was not yet ready for Preissig's high quality products and avant-garde ideas, and his enterprise soon failed and had to be sold. In 1907 the first one-man exhibition of Preissig's prints was held in Prague at Salon Topič. Despite a very favourable reaction from critics, the exhibition did little to improve Preissig's prospects and three years later he left for the USA. Here, after some initial struggle, he ended up as

the principal of the School of Graphic Arts at the Wentworth Institute in Boston. But he could not properly concentrate on his own work and missed his home country, and so he returned to Czechoslovakia in 1930. Surprisingly, he created a number of abstract paintings which are the most interesting part of his work from this period. During the war he was in the Resistance; he was arrested in 1941 and died in a concentration camp.

Preissig is recognised as the first modern Czech graphic artist to cover many areas of graphic design. Of particular importance are his applied graphics, especially book design. His style had its roots in Art Nouveau, but he went beyond the flamboyant decorativeness and developed a very refined, elegant style marked by simplicity and discipline.

He published a book on *Barevný lept a rytina* (Coloured Etching and Engraving); the first edition appeared in 1909, the second, enlarged and illustrated, in 1925.

Bibliography: Tomáš Vlček, *Vojtěch Preissig* (forthcoming)

In 1906 an album of twenty of Preissig's prints *Coloured Etchings* was published in New York with the English title. These were partly created in Paris, and partly in Prague after Preissig's return from France. They were destined for the American market, and the original plates and artist's proofs were taken to the States where Preissig's brother lived. Only a limited number of sets were left in Prague, where one was shown at Preissig's first exhibition in 1907. The following three prints come from this album, which is probably the most striking example of Japanese influence in Czech printmaking.

*14. The Seven Crows

1900–1906
Coloured Etching; 396 × 475mm
1985–11–9–80

This is an example of a fairy-tale theme, not unknown in Preissig's work. No.7 of the album is another story motif, *The Sprite*. Preissig also created a masterpiece of Czech illustration for children in Karafiat's *Broučci* (The Little Beatles). Preissig probably used two different plates to achieve the delicate colour effect.

15. Before the Storm

1900–1906
Coloured Etching; 397 × 195mm
1985–11–9–81
Annotated 'Paris et Prague'

A number of watercolours with trees were created as a preparatory basis for prints on the same theme.

*16. Winter Motif

1900–1906
Coloured Etching; 495 × 295mm
1985–11–9–82

A tree is a leitmotif of Preissig's prints, both for its symbolic meaning as a personification of nature and for purely artistic qualities as a means of dividing the field vertically. Within the album we find several examples of highly stylised, geometrically shaped trees or very complicated, widespread arabesque-like tree tops. In this print the tree dominates the quiet, peaceful atmosphere of the winter scenery.

2 The Symbolists

František Bílek

1872 Chýnov
1941 Chýnov

Primarily a sculptor and a printmaker, a versatile and extremely prolific artist who also wrote and illustrated books, made ceramics and designed buildings. Bílek was the most significant representative of the first generation of Symbolists and a deeply religious person for whom the spiritual content of his work was his first priority.

At the age of fifteen he entered the Prague Academy to study painting, but being partially colour-blind he abandoned this for sculpture, which he studied privately in Prague and in Paris at the Academie Colarossi (1891–2). From around 1900 he was involved in print-making, starting with drypoints and lithographs, and soon found his ideal medium in woodcut. It seemed only logical that he should turn to this. As a sculptor he worked mostly in wood and his sculptures had a painterly and graphical character, some of them being low reliefs with their surface densely cut in long vertical lines. Although he did not have many followers, his revival of the technique of woodcut was important for the next generation. He himself exploited its full potential, particularly the expressive use of contrast of light and shadow. For a long time Bílek's work seemed out of time and context of Czech art, and although as a personality he stood apart from his contemporaries, he was very much an Art Nouveau artist who influenced the second generation of Czech Symbolists. It was the following avant-garde generation of artists who often criticised him for the literary and philosophical content of his work.

Bibliography: František Šmejkal, 'Česka symbolistní grafika', Uměni, Vol.XVI, Prague 1968, pp.1–24
František Bílek – grafika, exhibition catalogue (by J.Wittlichová), Vlastivědné muzeum, Písek, 1965.

The three following prints were given to the British Museum by the Czech government following an exhibition of Czech prints in London and Brighton in 1927.

*17. Entrance to the Temple Vestibule

1905
Wood-engraving; 344 × 220mm
1927–12–10–21

The 'column-like' human figures and their dramatic gestures (heads and arms pointing upwards) convey Bílek's idea of mystical ecstasy, of redemption and integration with God and the Cosmos. The complicated philosophical message of the artist is often explained verbally somewhere on the edge of the print. This print is a good example of Bílek's favourite method of exploiting the texture of the wooden block as an expressive element.

*18. A Hurt Tree Telling a Weird Tale about the Committed Disease

1912
Wood-engraving; 227 × 293mm
1927–12–10–22

Print No. 2 from an album of 6 wood-engravings titled 'Meditation about the Human Body'.

19. Spiritual Meeting

1925
Wood-engraving; 229 × 164mm
1927–12–10–24
Signed

The same theme appeared in a wooden relief in 1916 and as a sculpture in 1925.

František Kobliha

1877 Prague
1962 Prague

Graphic artist, probably most significant representative of the second generation of Czech Symbolists and co-founder of Sursum. Kobliha was an active member of Hollar and frequently contributed articles to the association's own magazine and to *Moderní Revue*.

Although trained as a painter at the Prague Academy (1901–5), he was from the beginning of his career attracted to printmaking which at that time was not yet taught there. As with other artists, drawing served for a time as a substitute for printmaking.

After sporadic attempts from 1902, he took up print-making systematically in 1908, more or less abandoning painting. Wood-engraving remained his favourite technique for the rest of his life. His best prints belong to the first and second decade of this century. The main stimulus for his printmaking was *Moderní Revue*, where Symbolist literature and prints were frequently published. Among the authors who inspired Kobliha's prints were Nerval, Poe, Maeterlinck, Procházka and Hlaváček. Kobliha created several albums based on literary texts, they were not illustrations in the traditional sense, but rather variations or paraphrases, with many additional elements drawn from his own imagination and were frequently published independently of the text which inspired them. The Albums *Late towards Morning* and *Vindictive Cantatus* based on Hlaváček's poems are among the finest examples of Kobliha's early printmaking.

His subject-matter is visionary, phantasmic scenes with human and non-human creatures like vampires and phantoms, situated in a half-real, half-imaginary landscape. The quiet, melancholic atmosphere of night is a particularly favoured setting for his scenes with dreaming and longing figures. Kobliha shared his obsession with night with Odilon Redon, whose work he knew from *Moderní Revue*, and in an article about Redon's work he acknowledged his admiration for this artist.

After the First World War Kobliha continued printmaking, and tried out other techniques, such as lithography, but the power and attraction of his early prints is lacking and his style became rather conservative.

Bibliography: František Šmejkal, 'Básnik noci, k rané tvorbě Františka Koblihy', *Umění*, Prague 1974, pp.340–353

20–28. Tristan

20. Waterfall

21. Two Figures on Horseback

22. Ship on the Sea

*23. Wave

24. Seated Figure in a Wood

25. Figure on a Path

26. Figure by the Shore

27. Reclining Figure by Shore

*28. Two Standing Figures

Set of nine wood-engravings and a title page
Published by Marie Klíková, Prague
292 × 230mm
1909–11
1985–11–9–55 to 63

The album *Tristan* is one of Kobliha's key works. The old Celtic legend of the love of Tristan and Isolde was revived by Wagner in the opera first performed in 1865. Other Wagnerian themes had occurred in Kobliha's painting in 1901 and 1904. This is the best known version of his various illustrations of *Tristan*; in 1917 he added another two prints to the original eight and later in the 1920s he illustrated two books on the same theme.

Kobliha's aim is not to narrate a story. There is hardly any epic continuity, or dramatic development from one print to another, only repeated motifs of melancholic longing, waiting, and loneliness. They show a marked tendency towards Art Nouveau plane stylisation and decorativism, which can also be found in other of his prints. The contrast of black and white and the use of light penetrating the black areas to create ornamental patterns are important means of expression.

Josef Váchal

1884 Milavec near Domažlice
1969 Studeňany near Jičín

Highly original and versatile artist-craftsman who wrote, printed and illustrated books, and made prints, pictures, ceramics and furniture. Váchal's work is too exceptional to be easily categorised, but as a member of Sursum he belonged to the younger generation of Symbolists.

He grew up in his grandfather's house in South Bohemia. His father arranged for him to be trained as a bookbinder, and later he learned painting and print-making (under A. Hervert) in private schools in Prague. Nevertheless, more important than any training for Váchal was his own experience gained through experiment and hard work. His strong inclination to spiritualism and mysticism (which lasted throughout his life) was partly instigated by his father who introduced him at an early age to a community of theosophs, spiritualists and occultists. Váchal's imagination, nourished by diabolical visions, dreams, and hallucinations seemed to be inexhaustible.

Prints as such are not very numerous, and the majority belong to the early and final phases of his work. He made his first serious attempts in woodcut around 1910, and in this technique Váchal became a true master. He developed a unique method of multi-coloured printing from one block and explained this in a book published in an edition of seven in 1934 under the title *Receptář barevného dřevorytu* (*Recipe Book of a Coloured Wood-engraving*), illustrated with thirty-six coloured prints made in this technique.

The most exciting part of Váchal's work is his books. He was often author of the text which in the manner of fifteenth-century blockbooks, or the illuminated books of William Blake, were cut out of one block with the pictures. He used to do all the printing and binding himself, and afterwards destroyed the blocks, so that his books exist in only one or a small number of copies.

As a highly individual artist, Váchal stood outside the art scene (apart from early years with Sursum) and did not have any direct followers. He represents a wonderful type of artist-craftsman for whom hardly any laws in life and art existed and who achieved maximum personal and artistic freedom.

Bibliography:
J.A.B., 'Josef Váchal a jeho dílo', *Veraikon*, Prague 1934, p.52
Josef Váchal, exhibition catalogue, Galerie hlavního města Prahy, 1966 (by Marcela Mrázová-Schusterová)

*29. Salome

1909
Woodcut; 204 × 141mm
1985–11–9–120
Signed

Around 1906 Váchal started working with wood and knife, cutting small wooden sculptures and eventually woodcuts, abandoning for ever other printing methods.

Salome is one of the earliest woodcuts by Váchal, which appears unusually modern in its simplicity of form.

*30. Evening

1913
Colour wood-engraving; 206 × 207mm
1985–11–9–121
Signed and dated

Despite the great originality of Váchal's work, there are many examples to show how strongly he was influenced by the work of other artists, in this case above all by Gauguin. The dog serves as a reminder that Váchal appreciated dogs more than human beings. He admitted that he was more sorry about the death of his beloved 'Voříšek' than of his wife.

31. Enchantress

Part of an album of four prints titled *Sorcerer's Kitchen*
1929
Colour wood-engravings; 240 × 323mm
1985–11–9–122
Signed

The figures of witches, enchantresses and similar 'horrible woman creatures' as appeared in Váchal's hallucinations and nightmares and subsequently in his prints are said to have their origin in Váchal's unhappy relationship with his mother. As a child he was rejected by her and their relationship did not much improve later.

Jan Konůpek

1883 Mladá Boleslav
1950 Prague

Graphic artist, illustrator.

One of the founder members of Sursum and from 1920 active member of Hollar.

Studied architecture at the Prague Polytechnic (1903–6) and painting at the Academy (1906–8). Like some other artists at this time, he was attracted to printmaking after making drawings of old Prague architecture. He learned etching partly privately and partly by copying old masters, namely Rembrandt. As he explained in an article about his work published in the first issue of *Hollar*, he found printmaking less time-consuming than painting and more suitable for his modest working conditions (at that time he was a full time teacher and his kitchen was his studio). Konůpek was widely read, and published many articles about printmaking in contemporary magazines. He soon became involved in book illustration, where his narrative skills and sense of drama were best employed; during his life it was as an illustrator and a book-designer that he was highly regarded. Nowadays it is his less known early drawings and prints with strong late Art Nouveau features and Symbolist content that are most appreciated. His later work, always burdened with literary connotations, appears over-dramatic and often lacks appeal.

Bibliography: J. Žižka, *Grafické dílo Jana Konůpka*, Prague 1943

32. West Bohemian Baroque

1917
Etching; 392 × 294mm
1985–11–9–66

This print belongs to an album *Devět leptů (Nine Etchings)*, published by Emil Pacovský in *Veraikon* in 1918.

33. In Memoriam Otakar Březina

1929
Etching; 293 × 230mm
1985–11–9–65
Signed

Otakar Březina (1868–1929) was an outstanding Czech Symbolist poet; in this print Konůpek pays tribute to someone to whom he felt close affinity.

*34. Ancestors

1938
Etching; 341 × 415mm
1985–11–9–64
Signed and titled

3 The Cubists and the Tvrdošíjní

Josef Čapek

1887 Hronov (Moravia)
1945 Concentration camp Bergen Belsen

Painter, graphic artist, writer, art critic and theoretician.

While still a student at the School of Decorative Arts (1904–10) he started writing, and soon after published novels and plays written with his brother Karel, the famous novelist. As a member of several groups (SVU Mánes, Tvrdošíjní), and editor of various magazines, he was keenly involved in promoting contemporary art and in organising cultural life. His early paintings were influenced by Cubism, but his interpretation of Cubist principles was fairly unorthodox and even though geometrical forms prevailed for some time in his work, his own individual style soon emerged.

He was not properly trained in printmaking techniques (with only some private tuition), but prints form an important part of his work. His first attempts in lino- and woodcutting date back to his student years. Four of his linocuts were published in 1910 by S.K. Neumann together with work of other Symbolist and Secessionist artists (including Kobliha and Váchal). His interest in prints was further encouraged by the German magazines *Die Aktion* and *Der Sturm* which published his prints during the war, when there was no particular interest in his paintings or his prints in his own country. His first album was published in 1918 by Veraikon in Prague with a text by his brother. It contained ten linocuts and lithographs on topics such as The Beggar, Begging Children, Poor Women. Social themes appeared frequently in Čapek's prints (and paintings) in the late 1910s and the following two decades. More cheerful were his book-illustrations for children, where he ideally combined his love of literature with his skills as an illustrator and graphic designer. He created an entirely new style of book covers.

His deep love and concern for mankind culminated in the late thirties, when his writings and paintings expressed fear and criticism of current political developments. This led to five and half years in concentration camps, where he eventually died.

Bibliography: Jaroslav Slavík, 'Grafika Josefa Čapka', *Umění*, 1977, pp.61–68

35. Figure Called Lelio (*Frontispiece*)

1913
Etching; 340 × 230mm
1985–11–9–33
Signed, titled and dated

This print belongs to a group of variations of human figures and heads he created under the influence of Cubism around 1913–14. It is based on a painting in the National Gallery in Prague. This is probably the purest Cubist work that Čapek made and is certainly one of the most important Czech Cubist prints.

36. Man with Raised Arms

1913
Etching; 150 × 99mm
1985–11–9–35

One of Čapek's first prints in the Cubist style, presumably based on a similar painting which is known to have been made in the same year. It reveals how freely Čapek employed Cubist principles.

*37. Prostitute

1918–19
Linocut; 145 × 171mm
1985–11–9–36

Around 1918 the theme of prostitutes can be found frequently in Čapek's paintings, drawings and prints, they also appear as illustrations to Apollinaire's poems. Other linocuts ('Drunkards', 'In the Pub' and 'Poor Men') date to the same period and correspond in mood and style to those of 'Prostitute'. The technique of wood and lino-cutting suited Čapek's dynamic style as well as his sense for elementary form. In many ways this already shows Čapek at his most typical.

Bohumil Kubišta

1884 Vlčkovice
1918 Prague

Painter, theoretician, one of the chief representatives of Czech Expressionism and Cubism, member of Tvrdošíjní.

Studied for a short time at the School of Decorative Arts and at the Academy in Prague (1903–5), but was not happy there and after a year of military service went to study in Italy. In 1907 he returned to Prague to take part in the first exhibition of the Czech avant-garde group Osma (The Eight). With great enthusiasm he followed the main developments on the European art scene. In 1909 and 1910 he visited Paris where he saw paintings by Cézanne and the Cubists, and was involved in preparations for a major exhibition of French contemporary paintings in Prague. He frequently published articles and reviews on contemporary art in avant-garde magazines and from 1911 regularly took part in exhibitions of the Neue Secession in Berlin as well as in other Expressionist and Futurist exhibitions around Europe.

Poverty forced him to join the army in 1913 and as an army officer he spent most of the war in Yugoslavia isolated and condemned by his colleagues in Prague. He returned to Prague in 1918, and died shortly afterward from Spanish influenza.

The core of Kubišta's output is paintings created before the war. Here he employed some of the principles of Cubism, while at the same time remaining faithful to his own highly original symbolist theory of composition and colour. His first priority was always maximum expression and spiritual content.

Tragically, he did not live to see the success of his paintings. His first one-man exhibition was organised by his friend Jan Zrzavý two years after his death. For the younger generation Kubišta was an example of a devoted and determined artist whose unhappy life has been reflected to a great extent in his work.

Kubišta only occasionally turned to printmaking; less than thirty prints are known, mostly from the beginning and the end of his artistic career. He learned printmaking techniques privately from an engraver in Prague and studied with great interest prints by old masters including Rembrandt while in Italy. His first prints, rather elementary etchings dating between 1904 and 1907, were inspired by experiences from his own life. They feature, in a realistic manner, genre scenes from a pub, from an army dormitory, as well as country and domestic motifs, such as working dress-makers. Of the rare prints of his middle period is one based on a painting called *Old Prague Motif* made in 1912 when he was fully involved in discovering Cubism. During the war in Yugoslavia, he again devoted more time to wood- and lino-cutting, and created a group of prints inspired by local landscape and war events. These are totally different in style from his early work, and are striking and unusual for their almost playful ornamentalism and decorativeness.

Bibliography: Mahulena Nešlehová, *Bohumil Kubišta*, Prague 1984

*38. Plea

1913–14
Woodcut; 243 × 156mm
Nešlehová 267
1985–11–9–74
Published in Veraikon, Prague 1919–20

It is important to mention Kubišta's friendship with Jan Zrzavý in connection with this woodcut. They met in 1911 for the first time and were very close friends thereafter. Throughout their friendship we can follow very clear mutual influences in their work. His isolation from the Prague atmosphere heavy with Cubism gave Kubišta a chance to rethink his position towards Cubism, which he discussed in letters to Zrzavý. The woodcut 'Plea' shows a retreat from the Cubist's analysis towards solid form. The painting 'Meditation' and the sculpture 'Head' (both 1915) belong to the same group of work, where Kubišta, inspired by Egyptian and primitive art, concentrates on the voluminous human head as a centre of intense expression in a similar way to Zrzavý. This is undoubtedly one of the most important prints by Kubišta.

*39. Self-Portrait

Before 1918
Linocut; 227 × 152mm
Nešlehová 276
1985–11–9–75

Kubišta has painted a number of portraits of friends, relatives and of himself. Among his early etchings is a self-portrait (1907).

This linocut belongs to the latest period of Kubišta's work, and together with some landscapes from Istria was reproduced in the magazine *Červen*.

Emil Filla

1882 Chropyně
1953 Prague

Painter, printmaker, sculptor and prolific theoretician; founding member of Osma and SVU Mánes. Filla was a strong personality, an enthusiastic organiser of cultural life and co-editor of the major contemporary periodical on art *Volné Směry*.

After graduating from the Prague Academy in 1906, he made several trips to France and provided an important link between the Czech and French artists. He is now known mostly as a painter, but throughout his life he was involved in printmaking (with only a few periods when he did not make prints at all), often employing in prints the experience gained previously in paintings. The first lithograph by Filla 'Portrait of Dostojevsky' dates to 1908, and between then and 1953 he made 176 prints. He tried several techniques: lithography, drypoint and aquatint are the most frequent.

Filla was the most orthodox among Czech Cubists, and remained under the strong influence of Picasso even in the 1930s and 1940s when the majority of his prints originated. His first still-lives (linocuts) in Cubist style appeared in 1913. In the 1920s and 1930s this was still among his most frequent subject-matter in prints, although with the deteriorating political situation he turned to more serious themes. From 1935 the motif of Hercules and Theseus fighting animals appeared in his drawings, paintings and sculptures, and two years later in his prints as well. In this group of works, known later under the title *'Boje a zápasy'* (Fights and Struggles) Filla intended to issue a warning against Nazism; the imagery was an obvious metaphor for fighting an enemy, and the first three prints were even titled 'Nazism'. And punishment followed. On the first day of the Nazis' invasion of Czechoslovakia he was arrested and spent six years in a concentration camp, being released in 1945 in very poor health. He held a one-man show in Prague in the same year. After the war Filla finished the Hercules series, and continued with illustrations inspired by popular Czech songs and poems.

Bibliography: Čestmír Berka, *Grafické dílo Emila Filly*, Odeon, Prague 1968

40. Still-life with Mandolin and Tray

1931
Drypoint; 198 × 277mm
1985–11–9–38
Berka No.24
Signed, dated and numbered '16/30'

*41. Still-Life with Goblet, Pipe, Grapes and Apples

1931
Drypoint; 268 × 395mm
1985–11–9–39
Berka No.29
Signed, dated and numbered '7/30'

One of three unusually large prints made in 1931.

*42. Hercules fighting the Cretan Bull

1937
Drypoint with aquatint; 320 × 406mm
1985–11–9–40
Berka No.124
Signed and dated

One of the 15 prints on the theme of Hercules which, together with the five prints on the theme of fighting animals, form part of the group of works 'Boje a Zápasy'. In 1945 a title page and another thirteen prints were added and published both separately and as an album by Svatopluk Klír in 1946 in an edition of thirty-five with an introduction by a Czech poet František Halas.

Václav Špála

1885 Žlunice near Nový Bydžov
1946 Prague

Painter and printmaker.

He came from a large and not very wealthy family; his brother, an art teacher, supervised his artistic beginnings. Špála made several unsuccessful attempts to enter the School of Applied Arts in Prague, and finally enrolled at the Prague Academy but left before the end of his studies.

He was in close contact with his fellow students in the Academy who formed the famous Osma. Even though he did not take part in their first exhibition, his paintings fell under the same stylistic Cubo-Expressionistic influence as the other group members. In 1911 he visited France and after seeing Cézanne and the Fauvists, he was further encouraged in developing a style which became typical for him: bold colours, elementary geometrical shapes, and dynamic and rhythmical brush strokes. At this stage his paintings achieved nearly non-figurative form. Later Špála's style became more conservative although some features, above all the frequent use of intense blue, green, red and yellow, remained a distinctive mark throughout his work. Czech landscape, country women and flowers arranged in bouquets are his most frequent subject-matter, and derive from his youth in a small village and attachment to country life.

Špála was a painter for whom rich colours were of the utmost importance. Prints are not numerous and played only a marginal role in his work, being rarely mentioned in the literature on him. It seems that his printmaking became more intensive when he was a member of Tvrdošíjní, and like most of them chose linocut as his favourite technique as it was best suited to his dynamic expression. These prints were published in the periodical Červen.

The harmonious relationship between man and nature expressed in Špála's work, and its optimistic and joyful note gained him widespread recognition and in 1945 he was one of the first artists awarded the title 'National Artist', which is highest of its kind in Czechoslovakia.

Bibliography: Jiří Kotalík, *Václav Špála*, Prague 1972

43. Landscape

1917
Linocut; 140 × 115mm
1985−11−9−106
Signed and dated

An early example of Špala's printmaking. The elementary geometrical conception is very similar to Čapek's style.

*44. Autumn

1920
Linocut; 165 × 111mm
1985−11−9−107
Signed and dated

Country girls and women (along with the later flower bouquets) are probably the most frequent and typical of Špála's themes. In 1912 he painted a barefoot girl in simple clothes with a kerchief on her head, carrying a basket (The *Country Girl*, today in the National Gallery in Prague) and thereafter made many variations on this theme, mainly as oil paintings. In 1929 he created yet another version of this theme as a part of a group of the *Four Seasons*.

45. Song of the Country

1920−8
Hand-coloured linocut; 198 × 218mm
1985−11−9−108

Based on a painting of 1914. The hand colouring was added eight years after the linocut had been printed.

Jan Zrzavý

1890 Vadín near Německý Brod
1977 Prague

Painter, member of Sursum and Tvrdošíjní, one of the strongest and most original personalities among Czech artists. In 1966 awarded the title National Artist.

He studied at the School of Decorative Arts in Prague from 1907, but left dissatisfied before the end of his studies in 1909. He entered the world of art at a time when the atmosphere of Symbolism and the *fin-de-siècle* could be still be felt. In 1912 he took part in the first exhibition of Sursum.

For a short period his paintings were influenced by French Post-Impressionism, Expressionism and even Cubism, but more important than any contemporary sources were his studies of old masters and Leonardo da Vinci in particular. Being an individualist, he soon developed his own very original style which he followed with slight variations throughout his career. He never joined any school or belonged to any trend. Spiritually he was close to Surrealism, which he anticipated in many ways, above all by stressing the spiritual content, poetical character and symbolic meaning of his work.

Zrzavý worked in printmaking only rarely and most of his prints are based on his paintings (with the exception of some excellent book illustrations of nineteenth-century Czech poems). Among his first prints are lino- and woodcuts, but lithography suited the lyrical and poetical character of his works much better. Apart from the six prints listed below, Zrzavý made a few prints of still-lives with ships.

Bibliography: Miroslav Lamač, *Jan Zrzavý*, Prague 1980

46. Album of six lithographs

Cover

1. Lady with Veil.

2. Lovers.

3. Meditation.

*4. Grief.

5. Pain.

6. Toilette.

1918
317 × 240mm. Each signed and titled.
1985–11–9–123(1–6)
Published by E. Pacovský in *Veraikon*

These six lithographs, first published separately in *Veraikon*, and later as an album, are a key work among the rare prints by Zrzavý. They are all based on slightly earlier paintings. Zrzavý's style is shown here at its best. The anonymous, undetermined oval shaped faces, with very little detail, are personifications of various emotions and states of mind, and represent moments of spiritual intensity.

Rudolf Kremlička

1886 Kolín (Bohemia)
1932 Prague

Primarily a painter, and only occasionally made prints.

He graduated from the Prague Academy at a time when the new generation of artists was discovering Cubism and other contemporary art trends. He stood somewhat aside from this modernism. In 1910 he travelled to Holland, attracted by old Dutch masters, and to France to see Impressionist and Post-Impressionist paintings. Partly under their influence (especially of Degas, Manet and Renoir) he developed a personal style, which matured around 1920. It can be described as Neo-classical and can be seen in his numerous paintings based mostly on the theme of women at their toilette and working women, most frequently laundresses and washerwomen. Kremlička was probably the most significant representative of Neo-classicism in Czech painting in the 1920s.

Drawing, always important for him (he was an admirer of Ingres), led him eventually to lithography. This was around 1918 when he became member of Tvrdošíjní and his first print was then reproduced in *Červen*. The choice of subject matter for his prints is similar to that in his paintings. Although not very numerous, prints form an interesting part of Kremlička's work.

Bibliography:
František Kovárna, 'O grafice Rudolfa Kremličky', *Hollar XI*, 1936
Karel Holub, *Rudolf Kremlička* (in French and English), Pressfoto, Prague 1981

*47. Toilette

1922
Lithograph; 288 × 245mm
1985—11—9—73
Signed and dated

Also sometimes titled 'After the Bath' or 'Three Women'. Based on an oil painting from the same year.

*48. Young Girl Combing her Hair

1925
Lithograph; 455 × 305mm
1985—11—9—72
Signed and dated

Based on a painting of 1922.

Women at their toilette was the favourite theme of the members of Tvrdošíjní; Čapek, Kremlička, Zrzavý were all attracted by the endless possibilities it offered. While in Čapek's and Zrzavý's variations of women combing their hair, the shapes are stylised and rather geometrical, Kremlička's interpretation is very sensual.

4 The 'Social Trend'

Vladimír Silovský

1891 Libáň
1974 Prague

Graphic artist.

Trained partly in Zagreb (Yugoslovia), his decision to take up printmaking was influenced by an exhibition of the work of Frank Brangwyn he saw in Rijeka. In 1914 he returned to Prague and entered the recently opened Prints Department at the Prague Academy where he studied till 1917.

The focus of Silovský's interest was always people, anonymous crowds rather than individuals, and scenes from their ordinary life: rushing in the streets, waiting at a railway station, shopping at a market, etc. During the war his prints often featured poor and miserable people, and in this Silovský anticipated the so-called 'social trend' in printmaking of the 1920s. The same social and critical note emerges again in his prints of the streets of Paris which he visited in 1923 and 1924.

After the war and at the beginning of the 1920s he was fascinated by factory work and spent a great deal of time visiting industrial plants and sketching working people and their machines; these sketches formed the basis for later prints. Later in his career he turned to less serious themes, such as Prague architecture, landscape and portraits. Regardless of the subject he chose, he always paid exaggerated attention to the role of light and as a result the overall effect often borders on mannerism.

As the Head of the Prints Department at the Prague Academy he influenced a new generation of graphic artists who studied there after between 1945 and 1960.

Bibliography:
Blanka Stehlíková, *Sociální grafika žáků Švabinského školy*, Prague 1962
Ludvík Páleníček, Soupisný seznam grafického díla Vladimíra Silovského (forthcoming)

49. Countryside near Ostrava

1922
Woodcut; 270 × 326mm
1985–11–9–88
Páleníček 106
Signed, titled and dated

This woodcut belongs to a group of prints inspired by Ostrava, an industrial town in northern Moravia known for its major coal pits and steel factories. Silovský visited Ostrava in the early 1920s and prints created then often deal with the factory working atmosphere. 'Countryside near Ostrava' shows a scene with people resting under a tree, with the city, its factories and their chimneys in the background.

*50. Electric Tramcar

1926
Woodcut; 460 × 350mm
1985–11–9–89
Páleníček 145
Signed, titled, dated and numbered '18/50'

One of the most expressive prints by Silovský, showing a rather depressed carriage of people most probably returning from work, their tired, powerless bodies, swaying on the tram. The sharp contrasts of black and white and the general roughness of finish further strengthen the dramatic effect.

51. Street at Night

1936
Drypoint; 300 × 228mm
1985–11–9–90
Páleníček 253
Signed, titled, dated and numbered '17/50'.

Also known under the title 'The Pavement'. Together with the following print the 'Street at Night' is an example of Silovský's 'softer' approach to printmaking, both in the chosen technique and subject.

*52. By the Cinema

1938
Drypoint; 370 × 287mm
1985−11−9−91
Páleníček No.259
Signed, dated and annotated 'autorský tisk' (artist's proof)

Silovský is still attracted by crowds of people, but this time they are not rushing to work, but to enjoy themselves in a cinema.

Jan Rambousek

1895 Prague
1976 Prague

Painter and printmaker; a chief representative of the 'Social' trend in Czech printmaking in the 1920s, and founder and first editor of the periodical *Hollar*.

Trained at the Print Department at the Prague Academy, where he stayed as an assistant to Max Švabinský until 1929. In 1922 awarded a scholarship to study a year in Paris at the Academie des Beaux Arts with the reproductive engraver Waltner.

He came from a poor family, and his childhood spent in the proletarian outskirts of Prague was of vital importance for his work throughout his life. He fought as a soldier in the First World War and his first attempts in printmaking are mainly etchings of subjects deriving from his war experience and youth.

Rambousek was a prolific printmaker and created over 500 prints, the majority of them in the 1920s and 1930s. He also illustrated twenty-five books. Most contain strong social criticism, even the album from Paris called *From the City of Lights*. Colour lithography was his preferred and most successful technique. He wrote two books on printmaking.

Bibliography: B. Stehlíková, *Sociální grafika žáků Švabinského školy*, Prague 1962

The following three prints are from the album *Rabble* (containing altogether seven prints), published in an edition of forty in 1921 by F. Svoboda. Despite its relatively early date, this is a key work by Rambousek and a major work of the social trend in printmaking. It is the work of a mature artist and has the features typical of its author, such as the strong contrast between light and shadow as well as the overall dramatic (if not over-dramatic) effect. The prints are arranged in a narrative sequence: after 'Childhood' comes 'At work', 'After Work', 'Sad Pleasure', 'Revolt', 'The Last But One Station' and a tragical suicide in 'The End'.

*53. Title Page

1921
Lithograph; 447 × 325mm
1985−11−9−83
Signed and dated

This is autobiographical in part: Rambousek's mother used to carry him in a basket to work in exactly the same way as the woman in the print.

*54. At Work

No.2 in the album
1921
Lithograph; 447 × 325mm
1985−11−9−85
Signed and dated

55. Rage

No. 5 in the album
1921
Lithograph; 447 × 325mm
1985−11−9−84
Signed and dated

Vojtěch Sedláček

1892 Libčany by Hradec Králové
1973 Prague

Painter, printmaker, illustrator; one of the first of Švabinský's pupils at the newly opened Prints Department at the Prague Academy and a prominent representative of the 'Social' trend in Czechoslovak graphic art in the 1920s.

There are no major changes or dramatic developments in Sedláček's work. From the very beginning of his career he was attracted by country life and his earliest source of inspiration was his native region around the river Elbe. At this time his prints and paintings are often dominated by figures of working countrymen. He was also attracted by people who lived on the margins of society, like gypsies, wanderers and vagabonds; their presence in Sedláček's work introduces a romantic note.

In 1926 he moved to a village in the North Bohemian mountains called Orlické Hory and most of his paintings and prints originated there. He records in a realistic manner, and with particular lyricism, the natural changes in landscape throughout the day and year, as well as the ordinary life of the locals.

He made over 500 prints, mostly colour lithographs but with some etchings, lino and woodcuts as well. His paintings share the 'graphical' character of his prints, with line and drawing playing a major role in all his work.

Sedláček's work was highly appreciated in Czechoslovakia, and shown in numerous exhibitions in and outside the country. He was awarded several major government prizes.

Bibliography: Libuše Sýkorova, 'Grafické dílo Vojtěcha Sedláčka', Supplement to *Hollar*, Prague 1954

*56. Herdswoman

1920
Linocut; 152 × 200mm
1985–11–9–86
Sýkorová 17
Signed and annotated '*Pasačka, ze sborníku Výtvarného odboru Umělecké besedy Život*' (Herdswoman, from a periodical *Život* published by Umělecká Beseda)

An example of Sedláček's early printmaking, done while he was still at the Academy. Later he rarely used linocut.

*57. Forge II

1924
Engraving; 182 × 272mm
1985–11–9–87
Sýkorová 22
Signed, titled and dated

Yet another early print showing a busy workshop dominated by figures of working men and horses. Sedláček was well known for his love of horses (both as an owner and as an artist), evidence of which can frequently be found in his prints and paintings.

Miloslav Holý

1897 Prague
1974 Prague

Painter and graphic artist, pupil of Max Švabinský. With Kotík, Holan and Kotrba left Umělecká Beseda in 1924 and formed the so-called 'Social Group'.

He grew up in a proletarian and industrial part of Prague. Together with his friend Jan Rambousek he spent a great deal of time in the streets of Karlín and Libeň (at that time outskirts of Prague) and both later used their experience from these wanderings in their prints.

In 1921 he visited Germany and became acquainted with German Expressionism, the Neue Sachlichkeit, and Munch. Equally important was his first trip to France in 1923 (a second followed in 1927) and the streets of Paris became another source of inspiration for him. The way Holý presents life of ordinary people differs from Rambousek or Silovský. He watches people working, relaxing on a park bench, reading papers. The scenes are somewhat idyllic in feel without the social criticism present in the work of some of his colleagues. Holý was much more of a poet (and had many friends among poets). Like Kotík (to whose work he is sometimes very close indeed) he frequently introduces a lyrical and slightly primitive note at this stage in his career. Holý's interest in people and the human figure in general later diminished and from the end of 1920 he was increasingly attracted by the countryside.

Between 1947 and 1960 he was a professor and later President of the Prague Academy.

Bibliography: B. Stehlíková, *Sociální grafika žáků Švabinského školy*, Prague 1962

*58. Young Woman in Winter

1922
Linocut; 295 × 200mm
1985–11–9–45
Signed, dated and numbered '15/30'

At the beginning of the 1920s Holý created a whole series of linocuts and colour lithographs on the theme of young melancholic women (e.g. Young Woman in Park, On the Riverside, Two Young Women). Another version of this print exists as a colour lithograph.

The sombre melancholic mood of these prints reflect Holý's experience of Munch's work during his visit to Germany.

59. Street with a Pony

1923
Colour lithograph; 300 × 340mm
1985–11–9–46
Signed, dated and numbered '3/10'

Several of Švabinský's pupils experimented with colour lithography; Holý was encouraged to do so by his friend Rambousek. He uses very pale subtle colours and achieves an effect similar to watercolour.

*60. Clearing Snow

1924
Colour lithograph; 310 × 400mm
1985–11–9–47
Signed, dated and numbered '5/10'

Like the previous print, this is a typical example of Holý's work at the beginning of the 1920s. He deliberately makes the sturdy figures of men with their tools look clumsy and thus achieves a slightly primitive character.

Pravoslav Kotík

1889 Slabce near Rakovník
1970 Prague

Painter, who occasionally made prints and designed tapestry and stained glass.

Studied at the Prague School of Applied Arts and with Preisler at the Academy. Kotík is the type of artist who constantly sought new sources of inspiration and new ways of expression. As a result his work varies a great deal. His first etchings and linocuts made around 1909 are Symbolist in style. They were followed by linocuts in a Cubo-Expressionistic style, when Kotík moved close to the group Tvrdošíjní; although not a member, his prints were published in Červen.

Despite many changes in his style (in printmaking often depending on the technique used), one thing remained unchanged throughout his artistic career, and that is his intense interest in people. This culminated in his paintings and his prints of the early 1920s, in line with the so-called 'Social' trend. Life in the country and in a small town became a prime source of inspiration. Kotík turned to etching and lithography, which lent themselves to depicting slightly naive and deliberately primitive scenes with figures of robust fishermen, herdsmen, bricklayers, acrobats, children, and suchlike.

During the 1930s and later, Kotík's prints became less frequent. The album Grotesque published in 1945 is probably the best-known work of this period, and shows an altogether different style with features pointing towards the abstraction which emerged in Kotík's work during the 1950s.

Bibliography:
Václav Pilz, 'Poznámky ke grafické tvorbě a k dílu Pravoslava Kotíka', Hollar, Prague 1961
Ludmila Vachtová, Pravoslav Kotík, Prague 1965

61. At the Window

1926
Woodcut; 155 × 127mm
1985–11–9–70
Signed and dated

*62. Couple in a Park

1926
Woodcut; 148 × 174mm
1985–11–9–71
Signed and dated

5 The Surrealists and Group 42

Josef Šíma

1891 Jaroměř
1971 Paris

Painter and illustrator. Probably the best known of the artists represented in this catalogue due to the fact that he spent most of his life in France and his work has been shown in numerous exhibitions in and outside Czechoslovakia. The most important was held jointly in the National Gallery in Prague and in the Musée National d'Art Moderne in Paris in 1968.

Šíma lived and worked for a short time in Brno in Moravia before entering the Prague School of Decorative Arts and later the Academy. 1921 was a decisive year in his life; on the way back from a trip to Spain he decided to settle in Paris. He soon married a French woman and adopted French citizenship. While in France, he remained in touch with Czech artists and publishers and contributed to Czech magazines with articles and translations from French literature. He also became a member of the Prague group of poets and painters called Devětsil. As a painter he is often categorised as a Surrealist, thanks to the imaginative and symbolical qualities of his paintings. But in fact he never belonged to Breton's group and remained throughout his life faithful to the philosophy of the group of French poets and philosophers called Le Grand Jeu, of which he was a founding member in 1928. With Le Grand Jeu (and the Surrealists) he shared the conviction that the artist's individual emotional experience has to be his first priority, and he stressed the inner life and emotions as the main source of inspiration for artists. An ideal art – according to him – would combine poetry and painting.

The core of Šíma's work is in painting; as a printmaker he is known above all for his numerous illustrations to Czech and French books.

Bibliography:
Joseph Šíma, *Oeuvre Graphique et Amitié littéraire*, Bibliothèque Nationale, Paris 1979
Věra Linhartová, *Josef Šíma, ses amis, ses contemporaines*, Brussels 1974

*63. Drieu la Rochelle: La suite dans les idées

64. Jean Cocteau: Vocabulaire

*65. Guillaume Apollinaire: Pont Mirabeau

Three sheets from the album *Paris*
Published in 200 copies by Aventinum, Prague 1927
Etchings, hand coloured; 300 × 245mm
1985–11–9–102,103,104

Aventinum was a major progressive publishing house in Prague, which also ran an exhibition gallery. In a letter from Otakar Štorch-Marien, the owner of Aventinum, Šíma was asked to send between 15 and 20 illustrations in any technique he chose, in a maximum of three colours. The book contains twenty-eight poems by contemporary French poets, translated into Czech by Jaroslav Seifert, with an introduction by Philippe Soupault.

Altogether there are 18 etchings by Šíma in the book, all superb examples of his skills as a poet-painter. Needless to say, life in Paris inspired Šíma and these fragile, highly poetical etchings show his early style as developed during his first years in France. The imagery is already Surrealistic, and many features, such as the symbol of an egg, appear frequently in Šíma's later work.

František Tichý

1896 Prague
1961 Prague

Painter and graphic artist.

Trained in a lithographic workshop, also studying in evening drawing classes. Applied to enter Švabinský's Print Department at the Academy in Prague, but was not accepted and studied painting instead. In the 1920s he created his first lithographs, but only took up printmaking systematically much later in 1938. Between 1929 and 1936 he lived in France, creating mainly oil paintings (partly under the influence of French painters, such as Seurat) and some drawings which after his return to Prague he turned into drypoints. Despite his training drypoint became his favourite technique. The list of Tichý's prints published by František Dvořák in 1961 consists of 209 items, including designs for posters, *Ex Libris*, book illustrations, etc. In both painting and printmaking he created highly original and poetical work. Initially his prints often paralleled his paintings, but later they became more or less independent. After 1949 his graphic work significantly outnumbered his paintings.

Among Tichý's favourite subjects are the circus with its clowns, acrobats, magicians, and also the Commedia dell'Arte, musicians and animals. Tichý was an excellent draughtsman and although his work always remained figurative his interest went far beyond the natural form of the human figure. Themes like acrobats or clowns provided him with an ideal basis for endless exploring of shapes and lines. The unique poetic atmosphere of the circus, the element of joy and sadness in circus clowns, and the extreme situation of acrobats, must all be understood in a symbolic sense as corresponding with Tichý's feelings and reflecting his emotional experience. The tragi-comic polarity attracted Tichý again and again, and significantly he closed his career in 1957 with a print called 'The Chimera of Don Quixote'.

Tichý has an important place among Czech artists and especially in prints stands out markedly against his contemporaries. Already when in Paris, he was recognised in Prague as an outstanding artist. In many ways he occupied an intermediate position between the pre-war generation of graphic artists and the young generation who started their careers after the Second World War.

Bibliography: František Dvořák, *František Tichý, grafická tvorba*, Prague 1960

*66. Clown with Lamp

1938
Drypoint; 300 × 234mm
1985−11−9−115
Dvořák No.22
Signed and dated

This is considered to be the first really accomplished drypoint by Tichý. It is based on a coloured drawing of 1937. Light is an important element here, and the interrupted line and the way light penetrates the figure is reminiscent of Tichý's favourite painter, Seurat. This fine effect is helped by careful wiping of the plate.

*67. Trapeze Acrobats

1943
Drypoint; 263 × 200mm
1985−11−9−116
Dvořák No.26
Signed

The theme of a trapeze acrobat already appears in the first print by Tichý in 1921 (although depicted in quite a different manner), and there are many later variations in oil paintings, drawings and prints. This particular print is based on a pen drawing of the same year.

*68. Paganini II

1945
Drypoint; 282 × 200mm
1985−11−9−117
Dvořák No.117
Signed and dated

Tichý was fascinated by Paganini both by his ingenuity as a musician and by his demonic appearance. The first variation appeared in 1942, and several more followed.

Kamil Lhoták

1912 Prague

Painter and graphic artist, illustrator, film-maker and writer; member of Group 42.

Self taught, influenced partly by Surrealism, his first public entry into the world of art was in 1939, when he held his first exhibition of paintings in Prague. Like the other members of Group 42, his paintings and prints are statements about the relationship between man, civilisation and nature. Lhoták created an entirely 'new' old world in which he returned to the pioneering years of explorers and inventors, with their flying balloons, airships, old aeroplanes, cars and bicycles. His work is imbued with considerable romanticism and nostalgia, and its originality and special charm has made it very popular in Czechoslovakia.

Lhoták's output in printmaking is quite extensive, although rather irregular with long intervals when he made no prints at all. His first drypoint appeared in 1944, and along with lithography, is his most favoured technique. He is a prolific printmaker, by 1964 he had created around 450 prints. They are often arranged in albums of which two inspired by his stay in Paris are of particular interest (*Paris in 1913, Paris in 1947*).

Bibliography:
František Dvořák, *Kamil Lhoták*, Prague, 1985
František Dvořák, 'Soupis grafického díla Kamila Lhotáka', Supplement to *Hollar*, Prague 1962
Kamil Lhoták, *Graphik*, exhibition catalogue, Stadthalle Freiburg am Breisgau, W. Germany, 1969

*69. Boulder

1967
Colour lithograph; 501 × 655mm
1985–11–9–78
Signed, dated and numbered '44/50'

This lithograph, along with the following, belong to a new group of work which emerged around 1962. Lhoták has abandoned his usual imagery of old cars, bicycles, etc. in order to concentrate on more purely formal concerns. This lithograph was printed in five colours. A similar boulder appears in an oil painting made a year later.

*70. Countryside

1968
Drypoint; 495 × 642mm
1985–11–9–79
Signed and dated

Among the possibilities that Lhoták explores are simple geometrical shapes, such as gigantic round apples, or conical tents, in an open landscape.

František Gross

1909 Nová Paka

Painter and graphic artist, member of Group 42.

Learned printmaking at the School of Applied Arts (1928–31) under Professor Kysela. Although his first lithographs and linocuts appeared in the early 1930s, Gross took up printmaking seriously only when he joined Group 42 in the 1940s. Even then his attitude towards the medium was different from the other group members. For him printmaking was not an autonomous creative activity, but was used to develop and 'store' ideas, and for colour experiments. The most satisfying variations he then executed as oil paintings. His output was quite large being mainly lithographs and drypoints, and later also linocuts and monotypes. Gross was strongly influenced by Surrealism in the mid thirties, when his sense for absurd combinations and situations first awoke. Later, as a member of Group 42, he shared the group's interest in modern civilisation and in machines as its symbol. Urban themes, streets and yards with factories, wires and chimneys and above all various fantastic constructions and machines of unidentified functions became more frequent. The compositions of his paintings and prints became very complicated and nearly abstract. In the 1950s he turned to a more realistic style.

Gross was honoured with several government awards for his paintings, and in 1961 received a Silver Medal at the 6th Bienniale in São Paulo.

Bibliography:
Jiří Kotalík, *František Gross*, Prague, 1963
Eva Petrová, 'Mýtus civilizace v obrazech malířů Skupiny 42', *Umění*, Prague, 1964, pp.231–250.

71. Seated Figure

1947
Hand-coloured drypoint; 133 × 89mm
1985–11–9–41
Signed, dated and annotated 'Zkušební tisk' (artist's proof)

This, along with the two following prints, is a wonderful example of Gross's semi-abstract style from the mid 1940s, with man-machine figures so typical of him. Hand coloured prints sometimes served as a basis for oil paintings.

*72. Seated Figure

1947
Hand-coloured drypoint; 158 × 120mm
1985–11–9–42
Signed and dated

73. Two Figures

1947
Drypoint; 108 × 79mm
1985–11–9–43
Signed

František Hudeček

1909 Němčice near Holešov

Painter, graphic artist, illustrator, a founding member of Group 42.

In 1931 he graduated from the School of Applied Arts in Prague and from then onwards was involved in printmaking, although not many early prints survive. During the 1940s, especially in the last months of the war and thereafter, his printmaking activity was fairly intensive. He is less interested in urban themes as such than other group members. The focus of his attention is man as a city inhabitant and, moreover, as a part of the universe. Hudeček was particularly inspired by the contrast of the dark night and bright stars with the city lights, as experienced on one of his walks during a frosty night in 1940. The motif of a night walker surrounded and shot through with a complicated network of lines on the black background, or as a bearer of various cosmic signs, appeared in numerous paintings and prints. Hudeček's cool sense for geometrical composition was here balanced by the poetical imagery which is marked by a strong feeling of melancholy and mystery. In Hudeček's later prints the geometrical element prevails and the composition becomes nearly abstract.

Unfortunately Hudeček did not pursue his career as a printmaker after the 1950s, although he continued to paint.

Bibliography: Eva Petrová, *František Hudeček*, Prague 1969

*74. Helter Skelter Park

1945
Etching; 120 × 154mm
1985–11–9–48
Signed and dated

A wonderful example of one of the fantastic landscape-machine constructions typical of members of Group 42. Other variations were the city-machine constructions. They all are unthinkable without the experience of Dada and Surrealism.

*75. Night Walker

1945
Etching; 295 × 227mm
1985–11–9–49
Signed and dated

Jan Smetana

1918

Painter and printmaker, member of Group 42.

Trained at the Polytechnic and at the Charles University in Prague. He is younger than other members of the group and entered the world of art later, which partly explains why his work was not under the influence of Surrealism which is evident in the works of his colleagues from the group.

Smetana's early works date to 1944, and he made a large number of prints between 1946–47. From the late 1940s he has only occasionally returned to print-making.

Prints often provided a basis for his paintings, or were created afterwards as paraphrases of paintings. Drypoint, lithography and aquatint are the techniques found most frequently. His prints follow the subject-matter of his paintings, which are almost exclusively on urban themes. Smetana's perspective views of streets with their houses, cars and people, are more straight-forward than is usual with the members of Group 42. Paris, which he visited after the war, provided an important source of themes, such as cafeterias, restaurants and metro stations.

Bibliography: Jan Smetana, Art Centrum, Prague 1973

76. The Outskirts

1944
Drypoint; 122 × 158mm
1985–11–9–98
Signed, dated and numbered '8/20'

An early, fragile drypoint showing Smetana's lyricism.

*77. Two Walkers in the Rain

1946
Etching with aquatint; 17 × 247mm
1985–11–9–99
Signed and dated

This print along with No.78 was acquired directly from the artist for the exchange with the British Museum. They were inspired by Smetana's stay in Paris.

*78. Paris Metro Station

1947
Drypoint; 245 × 325mm
1985–11–9–100
Signed and dated

Karel Souček

1915 Kročehlavy

Painter, graphic artist, illustrator; graduated from the Prague Academy, 1943–8 member of Group 42.

Unlike his colleagues in the group, he was less influenced by the poetry of Dada and Surrealism than by the crude reality of the industrial Bohemian town Kladno, where he spent part of his life. His interpretation of the 'man in city' theme typical of the group was more matter of fact, with an unusually critical note. His favourite themes were cheap restaurants and hairdressers' saloons, and the atmosphere of his paintings and prints is often depressing. Souček's prints have a painterly character, for by combining etching with aquatint he achieves an effect similar to brush strokes.

From 1958 until recently Souček taught at the Prague Academy. He was awarded several major prizes: in 1958 the Gold Medal at the Brussels World Fair, a Silver Medal at the Bienniale in São Paulo in 1959, and in 1974 the highest Czechoslovakian award of National Artist.

Bibliography: Eva Petrová, 'Mýtus civilizace v obrazech malířů Skupiny 42', *Umění*, Prague 1964, pp.131–150.

*79. Seamstress

1945
Coloured etching with aquatint; 205 × 157mm
1985–11–9–96

Printed from a single plate in two colours. The Seamstress is one of the themes which attracted Souček and Gross several times. Here we see Souček's dynamic and expressive style with figures almost disappearing in the tangle of lines.

*80. Children with Hoops

1945–6
Etching with aquatint; 250 × 160mm
1985–11–9–97

One of Souček's best-known prints. It shows the more lyrical and cheerful note in his work.

Jan Kotík

1916

Painter and graphic artist, occasionally designed for industry and produced unique pieces of glass, an active and enthusiastic promoter of contemporary art and prolific theoretician.

Son of the painter Pravoslav Kotík, he spent his childhood in Turnov and Mladá Boleslav, where he also learned lithography and typography before moving to Prague in 1934 and entering the School of Applied Arts there. His first wood- and linocuts (and later lithographs) date back to his student years and they often accompany literary texts. He was awarded a silver medal at the World's Fair in Paris in 1937 for his contribution to the Czech Pavilion.

In 1939 his first independent album of prints titled 'The Testament of Burning Country' appeared as a reaction to the Nazi occupation of Czechoslovakia. In the early 1940s he was one of the founding members of Group 42 and his output of prints increased at that time. He also frequently travelled abroad and shared his knowledge of contemporary developments in European art with others. During the Stalinist era in the 1950s he worked mainly in industrial design, glass making and book design, since his abstract paintings could not be made public. In 1957 he was awarded Second Prize at the Brussels World Fair for his monumental glass sculpture. In the same year his first one-man show was held in Prague. During the 1960s Kotík was again very active in various artistic fields, and published a collection of his writings.

Since 1969 he has lived in West Berlin where he devotes most of his time to painting.

Bibliography: Jan Kotik, The Painterly Object, Exhibition Catalogue, Albright-Knox Art Gallery, Buffalo, New York, 1984

81. Tavern

1943
Drypint; 115 × 150mm
1985–11–9–67
Signed and dated

Kotík always experimented a great deal with shapes, lines, and colours, gradually losing the figurative basis in his work and ending up in the 1950s with purely abstract compositions. Here, in 1943, as a member of Group 42 and in accordance with their programme, he is still interested in the human figure, and in the ordinary life of man (where gathering in a pub is an everyday event). There is an element of humour and mystery in those 'shadow' figures as seen here.

*82. Card-Players

1944
Etching; 98 × 143mm
1985–11–9–68
Signed and numbered '6/20'

*83. Interior

1944
Etching; 157 × 215mm
1985–11–9–69
Signed

Josef Istler

1919 Prague

Painter.

Studied under W. Höfner in Yugoslavia (1938–9). He represents the second generation of Czech Surrealists, transferring some ideas of the pre-war movement to the post-war era and providing a link between the two. He was a member of the group Ra which was in contact with the movement of the *Surréalistes révolutionnaires* and Istler took part in their Congress in 1948 in Brussels. A year later he exhibited with the Cobra group in Amsterdam. His first paintings emerged around 1940 and by 1946 he had held his first exhibition in Prague. In the last two years of the War (as with Sklenář) Istler concentrated more on prints than before; his later prints are less numerous, although they still represent an important part of his work.

The phantom phenomena typical of his early work were personifications of his imaginary notions. Later, abstraction, another element, always to some extent present in his work, prevailed.

Bibliography: Jan Kříž, 'K. malířskému a grafickému dílu J. Istlera', *Výtvarné umění*, Prague 1968, pp.99–109

*84. January MCMXLV

1945
Set of five drypoints; 70 × 110mm
1985–11–9–50(1–5)

This purely abstract style is rare in Czech prints of this period.

*85. February MCMXLV

1945
Set of five drypoints; 170 × 190mm
1985–11–9–51(1–5)

6 The 1960s

Zdeněk Sklenář

1910 Lestina near Zagreb
1986 Prague

Painter, graphic artist, illustrator.

He studied at the School of Applied Arts in Prague (1929–1939), where he later became assistant in the Department of Applied Graphics. He entered the art world just before the Second World War, and although he did not join any group or follow closely any trend, his work, always imaginative and somewhat bizarre, betrays the influence of Surrealism. Apart from the last few war years when he devoted more time to prints, Sklenář's activity in printmaking was not very extensive, and was closely linked to his painting (and *vice versa*). Drypoint and colour lithography were his favourite techniques.

In 1955 Sklenář travelled to China. Under the influence of Asian culture his work became even more exotic. He was particularly impressed by Chinese calligraphy, which brought a major change in his style towards abstraction.

Bibliography: František Šmejkal, *Zdeněk Sklenář*, Prague (forthcoming)

86. House in the Garden

1945
Lithograph; 240 × 300mm
1985–11–9–92
Signed

An early example of Sklenář's printmaking, showing a marked influence of Surrealism.

87. Vyšehrad at Night

1950
Lithograph; 260 × 336mm
1985–11–9–93
Signed, titled, dated and annotated 'Zkušební tisk' (artist's proof)

Although it resembles a fairy-tale scene, this is an actual view of Vyšehrad in Prague, where high on the cliffs above the river from the tenth century onwards the prince's castle stood; the towers as seen here were re-built at the beginning of this century.

*88. Apollinaire

1964
Colour lithograph; 428 × 180mm
Signed, dated and annotated 'Zkušební tisk' (artist's proof)

One of the numerous portraits Sklenář made from the end of the 1950s under the influence of Chinese calligraphy.

*89. Arcimboldo

1972
Etching; 430 × 266mm
1985–11–9–95
Signed and dated

Sklenář was for years interested in the bizarre work of Giuseppe Arcimboldo (1527–93), the Italian artist who lived in Prague at the Hapsburg court of Rudolf II, and became in this way part of the history of Czech art. Sklenář gathered information on Arcimboldo from the late 1930s, travelled to Vienna especially to see his paintings and even went to Italy to get closer to his admired master. From 1946 he created numerous variations of Arcimboldo's portraits in painting, drawings and prints, and this became his favourite theme.

Vladimír Tesař

1924 Prague

Graphic artist and a prominent illustrator.

He started his career in printmaking in the 1950s. In 1958 he took part in an exhibition of contemporary prints in Prague, which introduced a number of young Czech graphic artists. Together with J. Šerých and F. Peterka he formed Group M57.

Tesař's prints are dynamic and expressive, conveying a strong emotional involvement on the part of the artist. The inspiration for his work is derived from reality, but his fantasy is very much involved in the creative process. He works mostly at night.

The following three prints are among Tesař's most significant works. They belong to a group of woodcuts made around 1960 conceived as symbols of states of mind, such as love, fear, passion.

Bibliography: Luboš Hlaváček, Současná československá grafika, Prague 1978

*90. Fear

1960
Colour woodcut; 400 × 300mm
1985–11–9–112
Signed, titled, dated and numbered '4/20'

91. Song

1960
Colour Woodcut; 400 × 300mm
1985–11–9–113
Signed, titled, dated and annotated 'Zkušební tisk' (artist's proof)

92. Revolt

1960
Colour woodcut; 400 × 300mm
1985–11–9–114
Signed, titled, dated and numbered '8/20'

Jiří John

1923 Třešť (Moravia)
1972 Prague

John represents the postwar middle generation of Czech printmakers and painters. Along with his wife Adriena Šimotová and Alena Kučerová he belonged to the group UB12 who started exhibiting together in 1962. From 1963 he taught at the Academy in Prague.

He was born and spent his youth in a small town in Moravia and the beauty of local countryside became an important source of inspiration for his work. His interest in graphic art began early in his life and he entered a specialised school for graphic artists before enrolling at the School of Decorative Arts in Prague in 1946.

John was a quiet and meditative type of artist and this is reflected in his art. Spiritually he was close to Šíma (whom he never met) and within the tradition of European painting he admired Seurat, Braque, Ernst and Morandi. Most of his inspiration was drawn from nature: its shapes, forms and textures as well as basic processes, like growing, freezing and melting attracted him. They were the starting point for the poetical and philosophical reflections displayed in his paintings and prints. It seems that the originality and the strongly lyrical and symbolical character of his prints were appreciated more abroad than in his own country and he received several prizes at international exhibitions, including the Silver Medal in São Paulo in 1963 and prizes in Ljubljana and San Marino in 1965. His drypoint 'Coast' was selected for a Portfolio on Eastern European Printmaking published by the Pratt Graphic Centre of New York in 1970.

Bibliography:
J. Zemina, 'Jiří John', *Výtvarné umění*, Prague 1966, pp.53–62.
J. Šetlík, *Jiří John*, Prague, Art Centrum, 1969

*93. Crystal

1965
Drypoint; 493 × 634mm
1985–11–9–52
Signed, dated and annotated E.A.

Various geological forms, like rocks and minerals, became subjects of his close observation and reflections on nature. In 1964 he painted two pictures with the same title as this print. John's prints are probably unthinkable in any other technique than drypoint which

he exploited to the full. The burr left in various thicknesses on the plate becomes an important component of the print, and as John usually did the printing himself, he could use the burr's irregularities when inking, achieving unusually rich tones and textures.

*94. Rushes

1971
Drypoint; 634 × 438mm
1985–11–9–53
Signed, dated and numbered '6/35'

One of the last prints John made before his untimely death in 1972. Again a very sophisticated drypoint.

Ladislav Čepelák

1924 Veltrusy

Graphic artist, illustrator.

He studied under V. Rada and V. Silovský at the Prague Academy between 1945 and 1950. Later he himself became the Head of the Prints Department there.

Čepelák is one of the many graphic artists who started their career after the Second World War. He was strongly attached to the place in the Bohemian countryside where he was born and grew up. In his early lithographs, probably still under the influence of his teacher Silovský, he paid more attention to figural themes, above all scenes of country-dancing vividly depicted but often in a rather sombre mood. Čepelák is best known for his prints of landscape views, arranged in albums, such as *Ploughing* and *Snow Furrows*. Again, the rather flat agricultural land around Slaný, divided into fields was the main source of inspiration. These prints are often based on drawings made from nature and betray a certain romanticism in their approach.

*95. Print from the album Snow Furrows

1966
Aquatint; 350 × 492mm
1985–11–9–36
Signed, dated and numbered '19/200'

Although Čepelák claims to be inspired by landscape, his prints are often nearly abstract in composition. In this print the contrast of white areas covered with snow and black bare fields with two intermediate shades of grey are achieved simply by biting the aquatint on the plate to four depths.

96. Print from the album Skies

1969
Aquatint; 243 × 298mm
1985–11–9–37
Signed, numbered '1/100'

Vladimír Boudník

1924 Prague
1968 Prague

Graphic artist, painter, and eccentric.

Graphic skills acquired at the School of Graphic Arts in Prague; later he had various jobs, such as a workman and a technical draughtsman, with ČKD Sokolovo, a major industrial concern in Prague, where he held his first exhibition.

Boudník was renowned for his almost fanatical effort to promote his highly unorthodox ideas about art. Between 1949 and 1951 he issued three manifestos outlining his programme called 'Explosionalism'. He wanted to turn everybody into artists, and encouraged people to look for art around them, in ordinary life and in nature – for Boudník rocks, skies, cracks in walls, etc. were the greatest pieces of art. Technique and formal training did not matter, but the intensity of individual experience and devotion did. In his manifestos and 'happenings' organised in Prague streets in the late 1940s he anticipated some of the movements of the 1960s.

Boudník's prints have been shown in numerous exhibitions, a group show 'Konfrontace' organised in artists' studios in Prague in 1960 was one of the most important, in which Boudník's work stood out markedly from the work of his contemporaries. In 1964 he took part in the exhibition 'D' and a year later a

major one-man show was organised in Prague. Although the quality of Boudník's prints varies, there is no doubt that he has created some of the best post-war prints in Czechoslovakia, and his avante-garde ideas, sheer idealism and enthusiasm had a great impact on many artists (not only printmakers) in Czechoslovakia. Up until 1956 drypoint was Boudník's preferred technique. After that he started using rather unorthodox and dynamic methods of printmaking, where physical energy played an important role.

In general, Boudník's graphics show three main methods of working: active, structural and magnetic. In active graphics he punctured the metal plate with a hammer or pressed various metal items into it. The plate was of irregular shape and some of the prints could be viewed from all sides without there being a top or bottom. Boudník often re-used and re-worked his plates later. Both prints shown here belong to the second group called structural graphics.

Bibliography: Bohumír Mráz, 'O Vladimíru Boudníkovi poněkud polemicky', *Výtvarné umění*, Prague 1966

97. Structural Graphic

1962–5
Mixed colour media; 170 × 190mm
1985–11–9–28
Signed and dated

The method used here is more or less the opposite to the previous one, the effect being achieved by adding various materials to the plate. Most often Boudník would use fast drying varnish which could be poured, incised, baked and could hold small pieces of sand or iron filings. The 'structure' was then inked and printed as a monotype. Colour was of great importance in this method. In this particular print a symmetrical design around a central axis has been transferred to the plate before printing, evidently from a folded sheet of paper.

*98. Rohrschach's Test

1966
Mixed method in red; 347 × 489mm
1985–11–9–29
Signed and dated

An example of structural graphic as described above, the title being derived from psychoanalysis. In Rohrschach's test the subject is asked to react to ten different ink-blots and his personality is judged by his or her interpretation of them.

Jiří Balcar

1929 Kolín (Bohemia)
1968 Prague

Painter and graphic artist, best known for his prints, poster designs, and illustrations.

He studied History of Art at the Charles University in Prague (1947–48) and graphic art with Tichý and Muzika at the School of Applied Arts in Prague (1948–53). His Expressionist paintings as exhibited at the end of the 1950s were not approved of by the Czech authorities and his one-man shows were forbidden. He then became one of the organisers of Prague's artistic and intellectual underground in the 1960s, and travelled abroad with the Black Theatre. In 1964 he spent six months at an International Invitational Seminar of Art at Farleigh-Dickinson University in Madison, USA. A year later he received the Gold Medal at the Modern Art Biennale in San Marino.

Prints are considered Balcar's prime field of artistic activity. They reflect his own experience with bureaucracy and feeling of the absurdity of life. People in his prints are anonymous, faceless figures indifferently sitting, waiting, staring, in similarly impersonal surroundings with lettering (which have no other than symbolic meaning) scattered around. The shades of whites, greys and blacks in his drypoints, etchings and aquatints reinforce this feeling of alienation. After his untimely death in a car accident in 1968, retrospective shows have been organised in Galeria Schwarz in Milan in 1969, and in the Jacques Baruch Gallery in Chicago in 1970 and 1979.

Bibliography: 'Jiří Balcar – the archives of an artist', exhibition catalogue, Jacques Baruch Gallery, Chicago 1979
Jiří Balcar, *Výběr z díla*, Krajské vlastivědné muzeum. Oblastni galerie výtvarného umění v Olomouci, 1981

*99. Plate X

1961
Aquatint; 320 × 164mm
1985–11–9–27
Signed, titled, dated and annotated E.A.

Different shades of grey and black have been achieved by biting to different depths, the white circle was stopped out when printing. Part of a portfolio of ten aquatints titled Plate I–X. This is the earliest print of the three presented here; in general Balcar's work around 1960 was more abstract than later in the 1960s.

100. Alphabet

1965
Etching and soft ground transfer; 323 × 165mm
1985–11–9–26

A rather sophisticated print; the faint letters were done by soft ground transfer, the other etched directly on the plate. To judge by the inscription 'São Paulo' on the verso, this print was presumably sent to São Paulo in 1965 for the Bienniale.

*101. At Table

1966
Drypoint and soft ground etching; 213 × 333mm
1985–11–9–25
Signed, dated, numbered '4/10', titled on the back

Alena Kučerová

1935 Prague

A highly experienced and internationally recognised graphic artist of the middle generation. Trained at the School of Graphic Arts (1950–4) and later in the School of Applied Arts under Professor Strnadel. With Jiří John and Adriena Šimotová she was a member of the group UB12.

She started with abstract drypoints, but soon discovered her own method of printing from a perforated tin plate, a method she continues to use and develop. This discovery must have taken place partly under the influence of Vladimír Boudník's 'active' graphics and partly due to the fact that she had to economise with scraps of metal instead of copper plate. The working process is physically demanding: like Boudník she uses a variety of non-printmaking tools, including a hammer and different sorts of punches. The perforated, torn, folded or cut plate became so important for her that she started showing it at exhibitions together with her prints not merely as a document, but as a piece of sculpture. Her themes are usually derived from ordinary life and from nature with images of swimming or running people and landscapes being particularly frequent. But in fact the subject-matter is less important than the technique itself, and its possibilities and its consequences are the focus of the artist's attention as the main means of expression. Since the 1960s she has taken part in many exhibitions in Czechoslovakia and abroad.

Bibliography:
Alena Kučerová, exhibition catalogue, Galerie Vincence Kramáře, Prague 1986
Geneviève Benamou, *L'art d' aujourd'hui en Tchécoslovaquie*, 1979
Cincinnati Art Museum, *Eastern Europe Printmakers*, exhibition catalogue, Cincinnati, USA, 1975

*102. Minerva

1968
Printed from a perforated and cut plate; 530 × 750mm
1985–11–9–76
Signed and dated

103. By the Sea

1969
Printed from a perforated plate; 530 × 750mm
1985–11–9–77
Signed and dated

An early perforation (first date to 1964), reminiscent of her abstract drypoints from the early 1960s. Sea and swimmers frequently inspire her work, and she has created whole albums of prints with similar subjects.

Technical Glossary

Aquatint

A variety of etching in which tone is created by fusing grains of rosin to the plate and etching it. The acid bites in pools around each grain; these hold sufficient ink to print a light grainy tone.

Drypoint

A process similar to etching except that the line is not bitten by acid but scratched with a needle.

Etching

A waxy ground is laid on a metal plate, through which the artist draws his design. The lines of exposed copper are then eaten away in an acid bath. After cleaning off the ground, the plate is inked so that the ink lies only in the bitten lines and the surface is wiped clean. The plate is printed by laying a sheet of paper over it and running both through a press under considerable pressure.

Lithography

A method of printing from stone or zinc. It relies on the fact that grease repels water. The design is drawn on the surface in some greasy medium. This is printed from in the following way: the surface is dampened with water which only settles on the unmarked areas since it is repelled by the grease in the drawing. The surface is then rolled over with greasy printing ink, which only adheres to the drawing, the water repelling it from the rest of the surface. Finally the ink is transferred to a sheet of paper by running paper and the printing surface together through a scraper press.

Soft-ground etching

A variety of etching which uses a soft etching ground. By laying a sheet of paper on top of the grounded plate and drawing on the paper, the ground is made to adhere to the underneath of the paper. A precise facsimile of the drawing is thus left in the ground and can be etched into the plate in the usual way.

Wood-engraving

Lines are incised into a block of very hard wood to create the design. Ink is then rolled over the surface of the block which is printed under light pressure onto a sheet of paper. The design stands out as white lines on a black ground.

(For fuller explanations, see Antony Griffiths, *Prints and Printmaking: an introduction to the history and techniques*, British Museum Publications, 1980.

Bibliography

The following bibliography is heavily weighted to publications in English or other western European languages. A few essential books and articles in Czech have however been included. Many of these are useful even for the non-Czech reader for their illustrations, and some have resumés in another language. The items have been arranged thematically within the three sections.

General: Czech History and Literature

R.W. Seton-Watson, *A History of the Czechs and Slovaks*, London 1943

S. Harrison Thomson, *Czechoslovakia in European History*, Princeton 1953

Victor S. Mamatey and R. Luza, *A History of the Czechoslovak Republic 1918–1948*, Princeton 1973

Arne Novak, *Czech Literature* (with a supplement by W. E. Harkins), Ann Arbor 1976

General: Czech Art

Encyklopedie českého výtvarného umění (Encyclopedia of Czech Visual Arts), Prague 1975

Tschechische Kunst 1878–1914 auf dem Weg in die Moderne, exhibition catalogue, Mathildenhöhe Darmstadt, 1985. Two volumes, one of the catalogue, the other of essays. Very richly illustrated.

Petr Wittlich, *Česká Secese*, Prague, 1982 (On Czech art nouveau; resumé in Russian, German and English)

Dessin tchèque du 20e siècle, exhibition catalogue, Paris (Musée national d'art moderne, Centre Georges Pompidou), 1983 (by František Šmejkal and Jana Claverie). The most useful single book in a Western language.

Douglas Cooper, *The Cubist Epoch*, Oxford and New York 1971. pp.150–5 deal with Czech Cubism.

Cubist Art in Czechoslovakia, exhibition catalogue, Arts Council, London (held at the Tate Gallery), 1967

M. Míčko, *Le Groupe 42*, Paris (Les Lettres Françaises), 1963

Eva Petrová, 'Mýtus civilizace v obrazech malířů Skupiny 42' (The Myth of Civilization in paintings of members of the Group 42), *Umění*, 1964, pp.231–50.

Aktuální tendence českého umění, Obrazy, sochy, grafika (Tendences actuelles de l'art tchèque), exhibition catalogue (in Czech and French), Prague 1966

Geneviève Benamou, *L'art aujourd'hui en Tchécoslovaquie*, 1979

General: Czech Printmaking

Jaroslav Pešina, *Česka moderní grafika* (Modern Czech Prints), Prague 1940

Luboš Hlaváček, *Současná československská grafika* (Contemporary Czechoslovak Prints), Prague 1964. Covers the years 1940–60.

Luboš Hlaváček, *Soucašná grafika I a II* (Contemporary Prints I & II), Prague, 1978. These three books above between them cover the whole of this century up to 1978.

Graphic Art of Czechoslovakia, catalogue of an exhibition of prints from the private collection of Henry J. John, The Cleveland Museum of Art, Ohio, 1922

Hollar, Society of Czech Graphic Art Prague, Exhibition of Members' Work under the auspices of the Society of Graphic Art in London, exhibition catalogue, London 1927. These two catalogues are now only of historical interest.

Blanka Stehlíková, *Sociální grafika žáků Švabinského školy* (Social Trend in the work of Švabinský's pupils), Prague 1962

František Šmejkal, 'Česka symbolistní grafika' (Czech Symbolist prints), *Umění* 1968, pp.1–24 (with French résumé)

Eastern European Printmakers, exhibition catalogue, Cincinnati Art Museum, Ohio 1975

Karen F. Beall, 'Prints from Eastern Europe', *Quarterly Journal of the Library of Congress*, Vol.37, No.1, Winter 1980, pp.74–113

Antonin Hartman, 'Eastern European Printmaking, Part 2: Czechoslovakia 1950 to present', *Print Review*, 1977 (Pratt Graphic Center, New York)

Walter Hopps and Meda Mladek, *Recent Graphics from Prague*, Corcoran Gallery, Du Pont Center, Washington DC, 1968

Contemporary Prints of Czechoslovakia, exhibition catalogue, National Gallery, Ottawa, 1968

Contemporary Czechoslovakian Printmakers: Collection Jacques Baruch, exhibition catalogue, Smithsonian Institution, Washington DC, 1979

Index of Artists (by catalogue number)

Plate 4

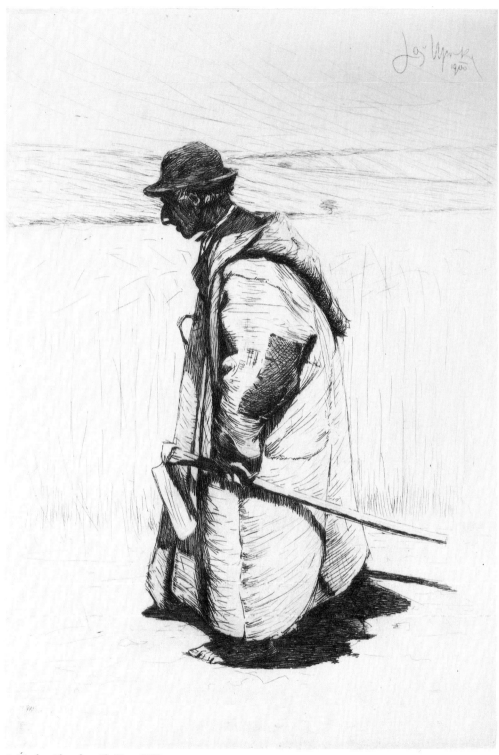

4 Úprka, Slovak with Hoe. 1900

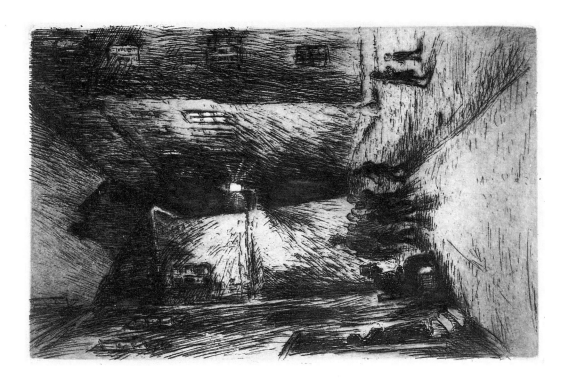

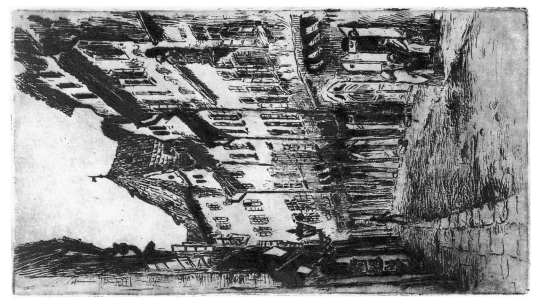

(Right)
2 Braunerová,
Platnéŕska Street.
1904

(Far right)
3 Braunerová,
Maislova Street.
1904

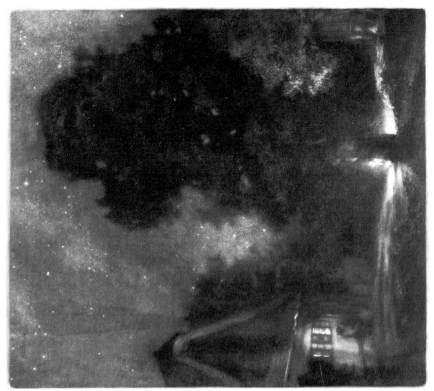

7 Švabinský, Summer Night. 1911

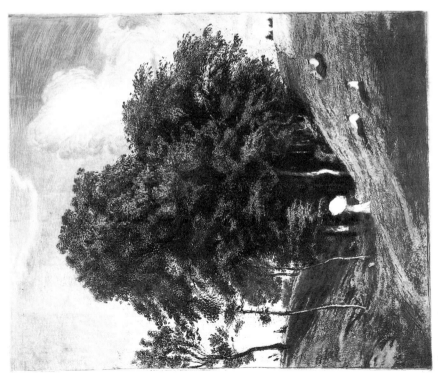

6 Švabinský, Summer Day. 1908

Plate 8

8 Švabinský, White Camelia. 1911

9 Hofbauer, Hradčany in Winter. 1903

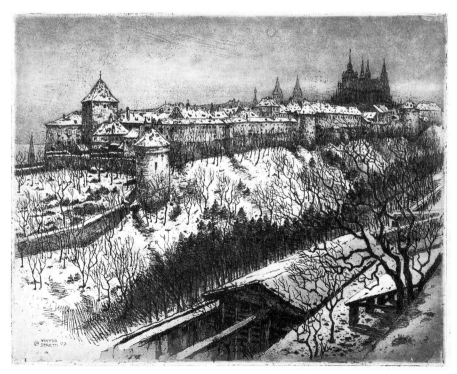

10 Stretti, View of Prague Castle from the Deer Moat. 1907

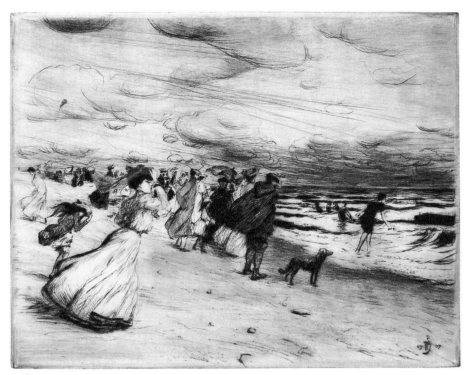

11 Šimon, The Wind. 1907

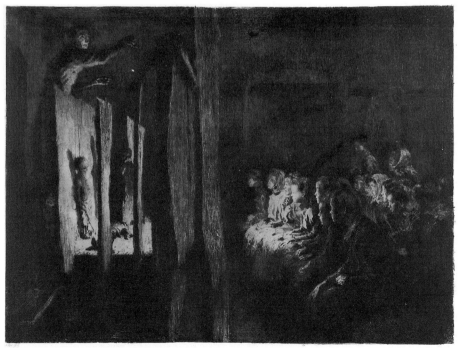

13 Kašpar, Puppet Theatre. 1906

Plate 14

14 Preissig, The Seven Ravens. 1900/6

Plate 16

16 Preissig, Winter Motif. 1900/6

(*Right*)
17 Bílek,
Entrance to the Temple
Vestibule. 1905

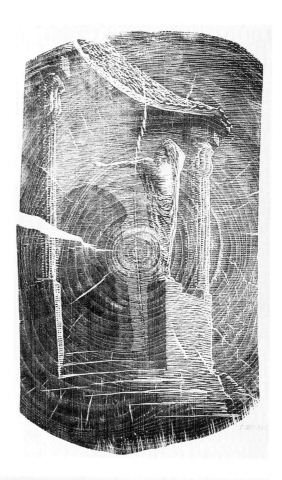

(*Below*)
18 Bílek,
A Hurt Tree telling a
Weird Tale. 1912

Plate 23

23 Kobliha, Wave. 1909–11

Plate 28

28 Kobliha, Two Standing Figures. 1909–11

29 Váchal,
Salome. 1909

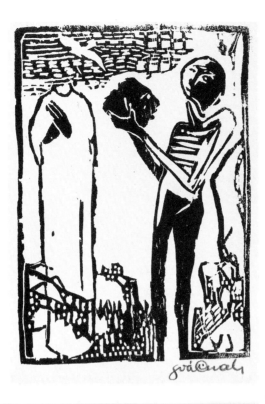

30 Váchal, Evening. 1913

34 Konůpek, Ancestors. 1938

37 Čapek, Prostitute. 1918–19

Plate 38

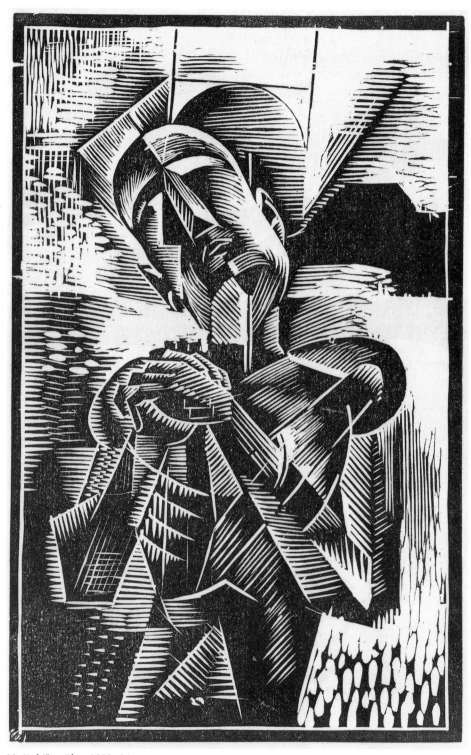

38 Kubišta, Plea. 1913–14

Plate 39

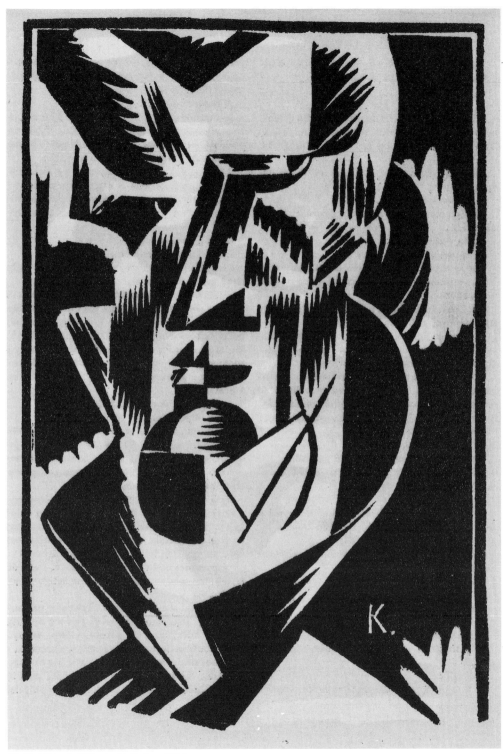

39 Kubišta, Self-Portrait. Before 1918

Plate 41

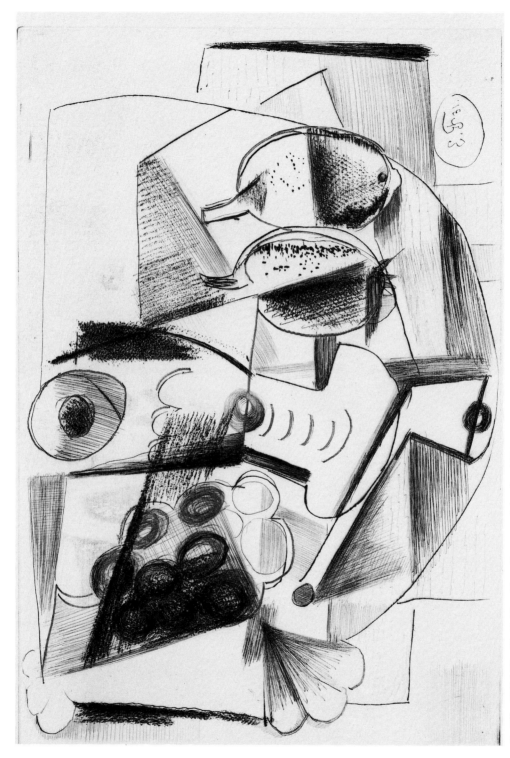

41 Filla, Still-Life with Goblet, Pipe, Grapes and Apples. 1931

Plate 42

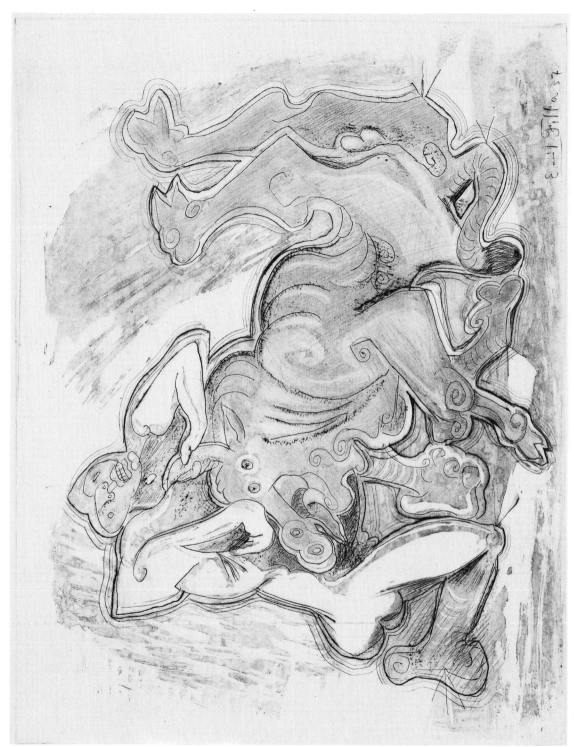

42 Filla, Hercules fighting the Cretan Bull. 1937

Plate 44

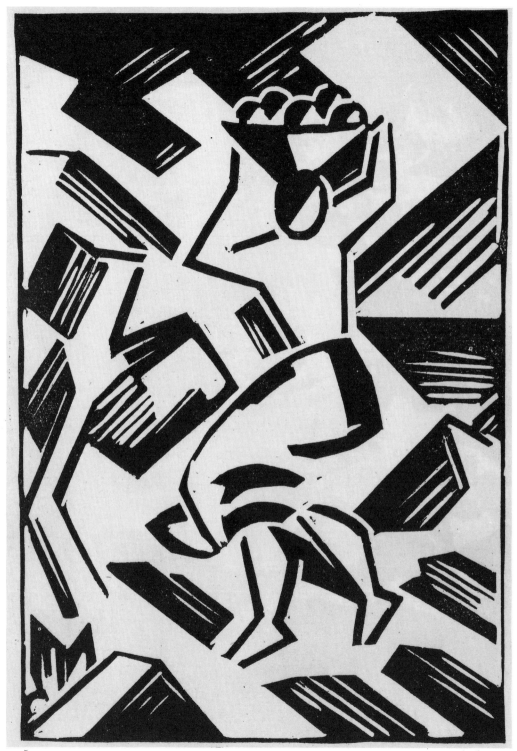

44 Špála, Autumn. 1920

Plate 46(4)

46(4) Zrzavý, Grief. 1918

Plate 46(6)

46(6) Zrzavý, Toilette. 1918

47 Kremlička,
Toilette. 1922

48 Kremlička,
Young Girl combing her Hair.
1925

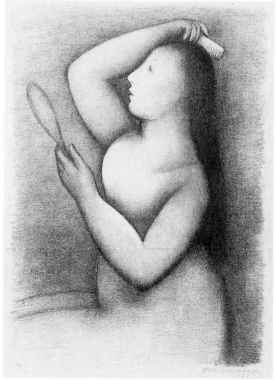

52 Silovský, By the Cinema. 1938

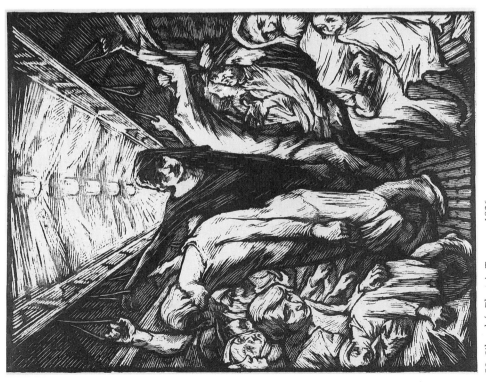

50 Silovský, Electric Tramcar. 1926

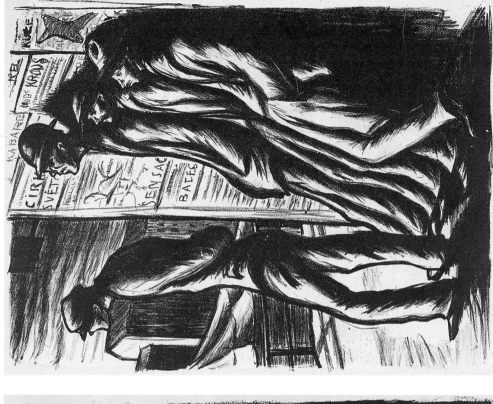

56 Sedláček, Herdswoman. 1920

57 Sedláček, Forge II. 1924

Plate 58

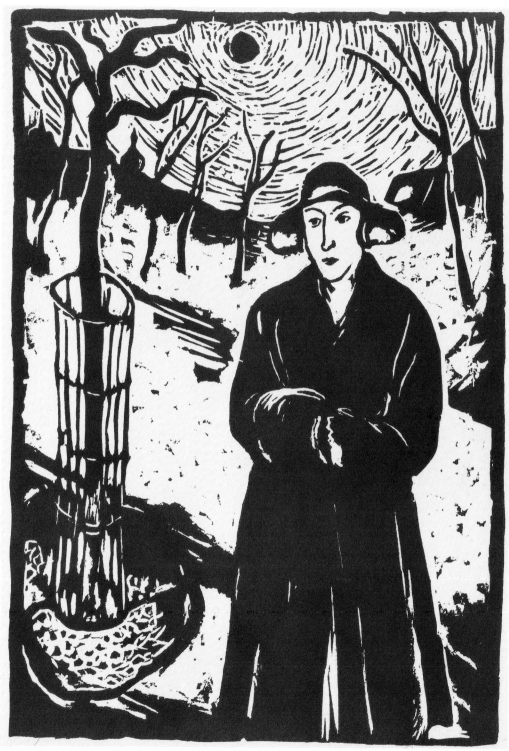

58 Holý, Young Woman in Winter. 1922

60 Holý,
Clearing Snow.
1924

62 Pravoslav Kotík,
Couple in a Park.
1926

Plate 63

63 Šíma, Drieu la Rochelle: La suite dans les idées. 1927

Plate 65

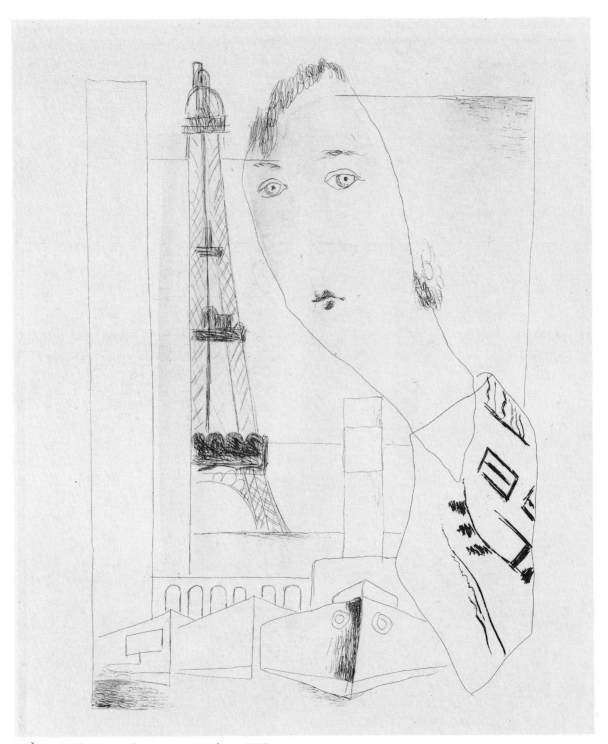

65 Šíma, Guillaume Apollinaire: Pont Mirabeau. 1927

Plate 66

66 Tichý, Clown with Lamp. 1938

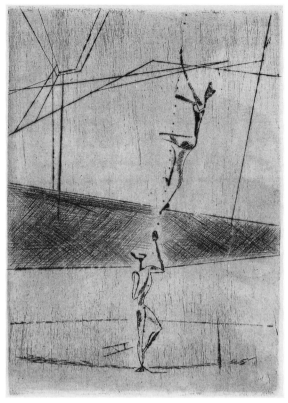

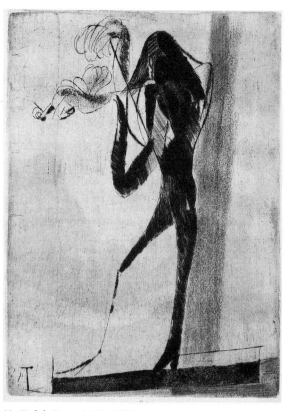

67 Tichý, Trapeze Acrobats. 1943

68 Tichý, Paganini II. 1945

69 Lhoták, Boulder. 1967

70 Lhoták, Countryside. 1968

Plate 72

72 Gross, Seated Figure. 1947

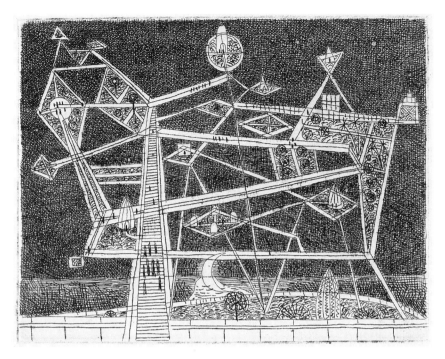

(*Above*)
74 Hudeček,
Helter Skelter Park.
1945

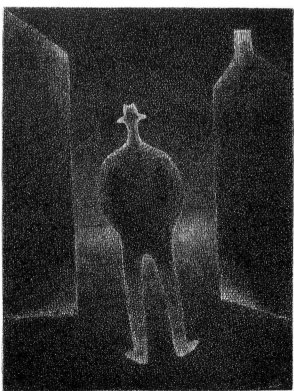

(*Right*)
75 Hudeček,
Night Walker.
1945

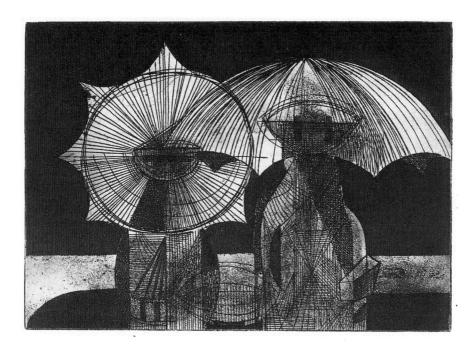

(*Above*)
77 Smetana,
Two Walkers in the
Rain. 1946

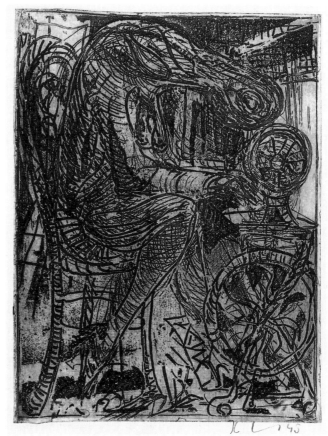

(*Right*)
79 Souček,
Seamstress,
1945

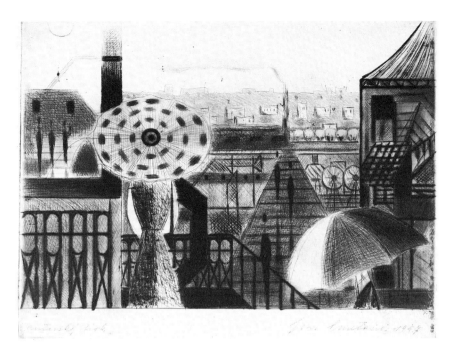

(*Above*)
78 Smetana,
Paris Metro Station.
1947

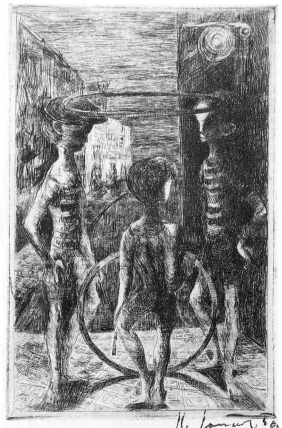

(*Right*)
80 Souček,
Children with Hoops.
1945−6

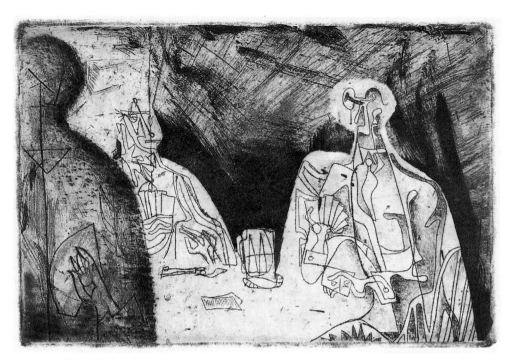

82 Jan Kotík, Card-Players. 1944

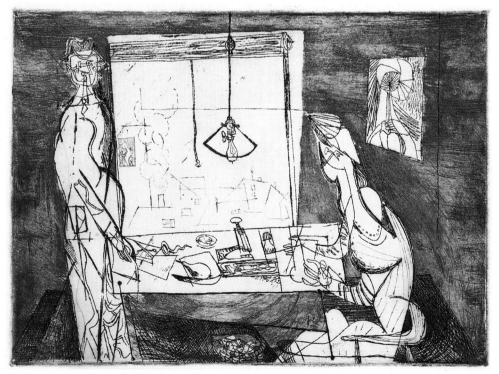

83 Jan Kotík, Interior. 1944

84 Istler, January MCMXLV

85 Istler, February MCMXLV

88 Sklenář, Apollinaire, 1964

89 Sklenář, Arcimboldo. 1972

Plate 90

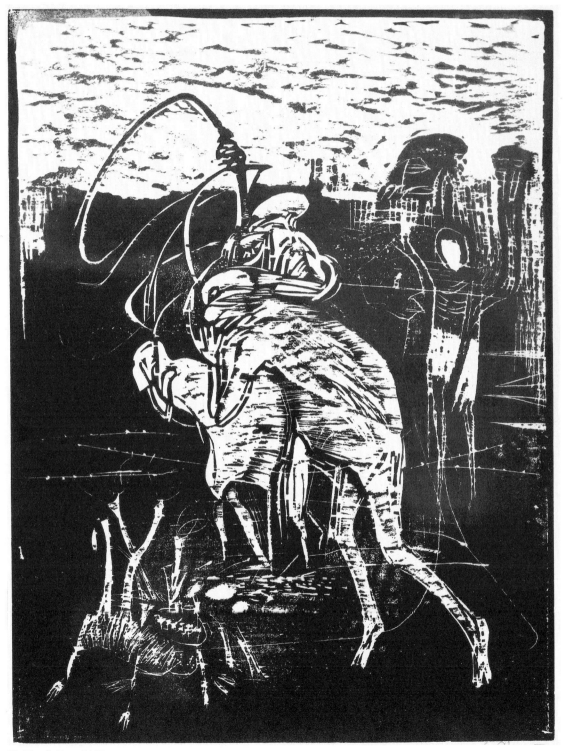

90 Tesař, Fear. 1960

Plate 93

93 John, Crystal. 1965

(*Right*)
94 John,
Rushes. 1971

(*Below*)
95 Čepelák,
From the album
'Snow Furrows'.
1966

Plate 98

Plate 102

102 Kučerová, Minerva. 1968